MW00609359

IMAGES
of America

BRIDGEPORT
AT WORK

In memory of my father,
Joseph S. Witkowski, 1919–1969.

IMAGES
of America

BRIDGEPORT
AT WORK

Mary K. Witkowski

ARCADIA

Copyright © 2002 by Mary K. Witkowski.
ISBN 0-7385-1123-4

First printed in 2002.

Published by Arcadia Publishing,
an imprint of Tempus Publishing, Inc.
2A Cumberland Street
Charleston, SC 29401

Printed in Great Britain.

Library of Congress Catalog Card Number: 2002110471

For all general information contact Arcadia Publishing at:
Telephone 843-853-2070
Fax 843-853-0044
E-Mail sales@arcadiapublishing.com

For customer service and orders:
Toll-Free 1-888-313-2665

Visit us on the internet at http://www.arcadiapublishing.com

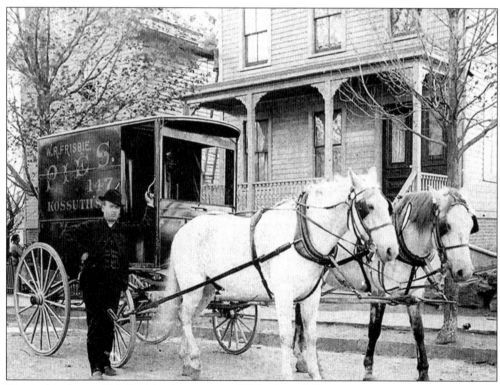

Pictured in front of his Frisbie pie wagon in 1880 is Joseph Frisbie.

Please note the following:
Page 4 pictures William Frisbie
Page 16 & 17: The Winter Quarters
were in Bridgeport from 1881-1927.

CONTENTS

ACKNOWLEDGMENTS

My sincere thanks go to the following:

Historical Collections staff of the Bridgeport Public Library, including Elizabeth Van Tuyl, Roseanne Mansfield, Luis Rodriguez, Sarah Greenberg, and pages Elis Espinal, Jennifer Samath, and Megan Golrick.

Michael Golrick, the library director, Ann Osbon, the assistant library director, and Vincent Wahn, the custodian who kept the library lights burning and brought water when I worked in the library after hours.

Charlie Walsh of the Connecticut Post for assisting me in deciphering the old Post photographs; Ben Ortiz, who was a fountain of knowledge and a great resource; and my old friend Tim Hill at the University of Chicago Press, for his good advice—sometimes I take it; sometimes I don't.

Bob Factor, who helped me on the fine points of accuracy; George Dragone, who made sure the Locomobile got its due credit; Duane Wetmore, who helped me carefully transport photographs back and forth; and my mother, Maureen, who gave me much encouragement.

Bridgeport Firefighters Historical Society, Rob Novak, John Cappiello of Bridgeport Hospital, Rose Bielin, Zoy Rountos, Ann Brignolo, Mark Heiss, the Padua family, Schwerdtle Stamp, Duke Bregleveri, Charles Brilvitch, Don Shea, Bob Berthelson, Fones School, Judith Box of the Queens Borough Public Library, Marshall Lewis of Davidson's, Michael Daly of the Connecticut Post, and Brad Durrell of the Bridgeport News, who was my editor for many years.

Photographers of the Connecticut Post and the old Bridgeport Herald, and Corbit Studios, for which a full credit appears on page 126 of this book.

Arcadia Publishing publisher Amy Sutton and editors W. Greg Scherban and Pam O'Neil.

INTRODUCTION

It's a mystery.

On every corner of Bridgeport, in a faded sign on the side of a building, on an aging storefront, or in the rows of factory buildings still lining pockets of the city, there are clues to the workers of Bridgeport's past.

A good detective could put these clues together to solve the mystery.

Who were the people who worked in these stores, in these factories; who painted the signs now faded?

Why did they create these now empty storefronts, towering fortresses, and block-long factories?

Collecting and deciphering the photographs of the last two centuries, one could figure out the thing that bound all the former Bridgeport citizens together: working together. Whether it was doing a job in a factory, raising a flag, helping to sell war bonds in World War I, developing public housing, or building a float for a parade, everyone was working together for the common good.

Most of the people in these photographs are not alive today. We can, however, look at the clues that they have left behind to see how their spirit and their work drove them through the obstacles of war, depression, and financial instability.

They say there is nothing new under the sun. Knowing that, revisiting these scenes of Bridgeport's best and worst times, we can all pause to reflect on these photographs and feel cheered that cities regenerate through the work of those who live there.

—Mary K. Witkowski

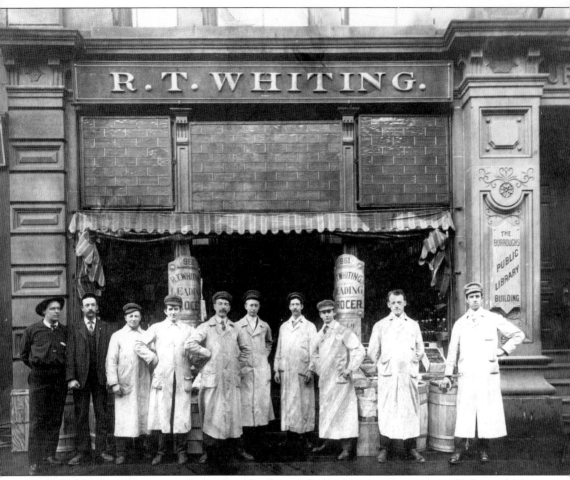

R.T. Whiting, Grocer was located in the Burroughs Building at the corner of John and Main Streets. Beginning in 1881, the original Bridgeport Public Library was located in this building. A sign for the library can be seen to the right of the men.

One
BEGINNING TO WORK

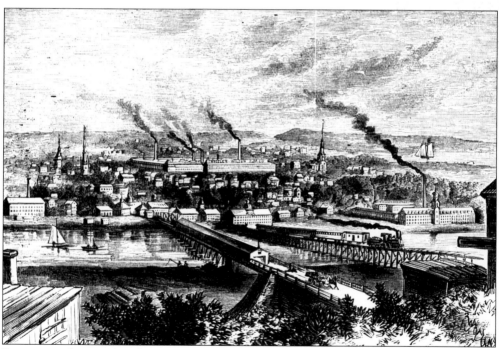

Drawn in the 1860s, this artist's depiction of East Bridgeport (from P.T. Barnum's autobiography, *Struggles and Triumphs*) shows the first growth of industry in Bridgeport. Alongside the church steeples are the smokestacks of Wheeler and Wilson Sewing Machine Company and the Howe Factory. Among the occupations of Bridgeport's earliest settlers were those of sea merchant, sailor, oysterman, whaler, merchant, tavern keeper, saddler, and tanner.

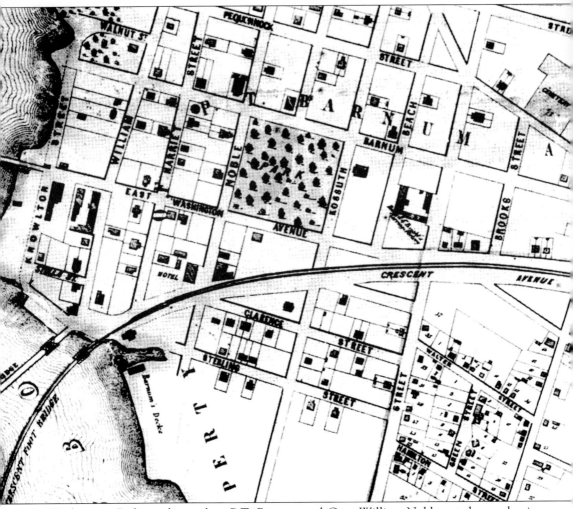

Washington Park was born when P.T. Barnum and Gen. William Noble acted as early city planners and developers, selling their land on the east side of the Pequonnock River in lots under the name New Pasture Lots. Envisioning an area of industrial development and worker housing, they named the streets after their own families. Helen Street was named after one of Barnum's daughters; Hallett was his wife's maiden name; and, of course, Noble and Barnum Avenues are still busy thoroughfares in Bridgeport's East Side. Shown is a segment of the 1857 map of Bridgeport.

The new development did not work out quite as planned. P.T. Barnum—museum curator, circus showman and the city's most famous resident—worked to attract friends and colleagues to settle in his hometown. Although Barnum's scheme to bring the Jerome Clock Company to the East Side failed and ruined Barnum financially, industrialists Elias Howe and Nathaniel Wheeler eventually located their factories in East Bridgeport. Here, Barnum stands with one of his successful endeavors, Commodore Nutt.

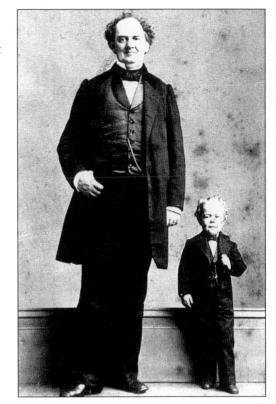

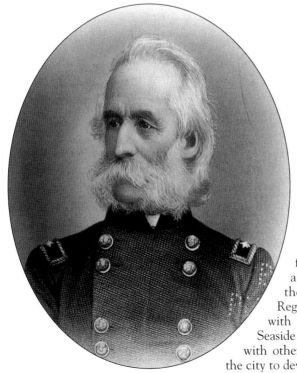

William Noble was an early land developer in the city who was a great friend of P.T. Barnum. Noble served as a general during the Civil War, leading the Connecticut 17th Volunteer Regiment in battle. Noble camped out with his troops in what is now known as Seaside Park. He and friend Barnum, along with other local residents, donated the land to the city to develop Seaside Park.

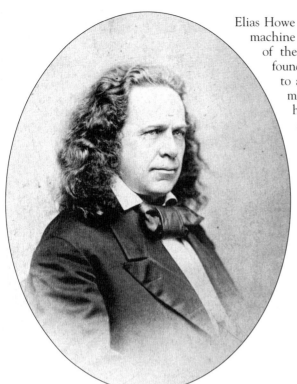

Elias Howe Jr. invented the first practical sewing machine and opened a factory along the banks of the Pequonnock River in 1863. Howe found the location convenient for shipping to and from New York. He was the first man to sign up for the Civil War; however, he was already 42 years old and in poor health, so he never served. He died three years later. In this (of course) black-and-white photograph of Howe, someone who obviously knew him wrote on the back of the photograph, "Brown hair—blue eyes—florid complexion," wanting to make sure the colorful character was remembered as he truly looked.

Nathaniel Wheeler was a public-spirited, generous man who became one of Bridgeport's wealthiest citizens. Born in Watertown, Massachusetts, in 1820, he and his wife, Mary, were involved in many community affairs.

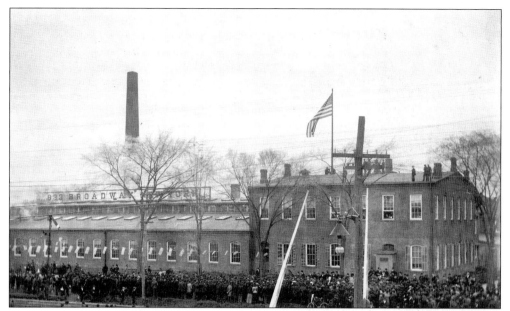

Nathaniel Wheeler and Allen Wilson moved their company to the former Jerome Clock factory in 1856. An early investor in the company was O.F. Winchester, head of the Winchester Repeating Arms Company in New Haven. This photograph of the sewing machine factory was taken in 1890 during a flag-raising ceremony.

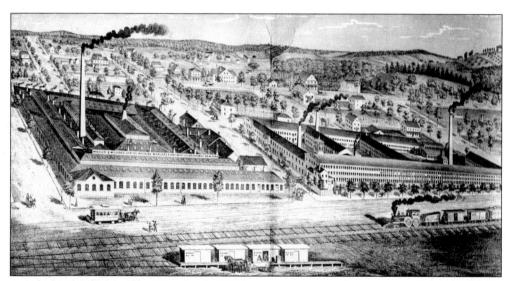

An idealized version of the Wheeler and Wilson factory shows the area around the workplace. Tree-lined streets, new houses, and picturesque settings were probably advertising not only for the company but also for the surrounding area. The proximity to the railroad made it easy to ship back and forth from New York.

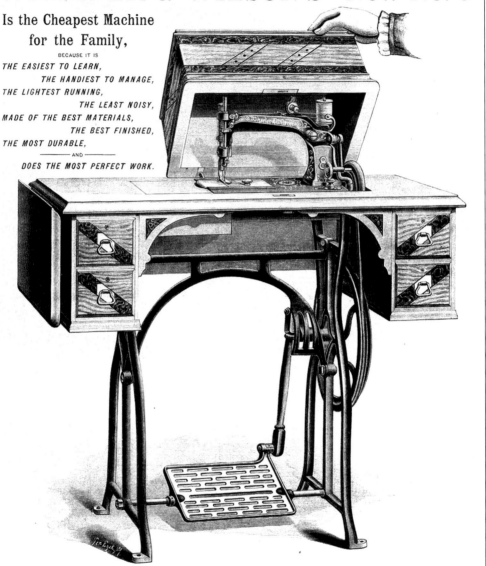

WHEELER & WILSON'S "New No. 8"

Is the Cheapest Machine for the Family,

BECAUSE IT IS

THE EASIEST TO LEARN,

THE HANDIEST TO MANAGE,

THE LIGHTEST RUNNING,

THE LEAST NOISY,

MADE OF THE BEST MATERIALS,

THE BEST FINISHED,

THE MOST DURABLE,

—— AND ——

DOES THE MOST PERFECT WORK.

SEWING MACHINES for family use, and every Grade of manufacturing in cloth or leather, adapted to run by hand, foot, or steam power. The New Wheeler & Wilson Automatic Button-hole Machine, just placed on the market, is superior in every particular. Address,

WHEELER & WILSON MANUFACTURING CO.,
BRIDGEPORT. CONN.

This 1890 advertisement for Wheeler and Wilson emphasized "easiest to learn" and "family" use. Women were at first reluctant to use sewing machines. Since all sewing had been done by hand, it was thought that the machine would replace the worker. However, women soon used the machines both at work and home. The elaborate cabinets were prized pieces of furniture.

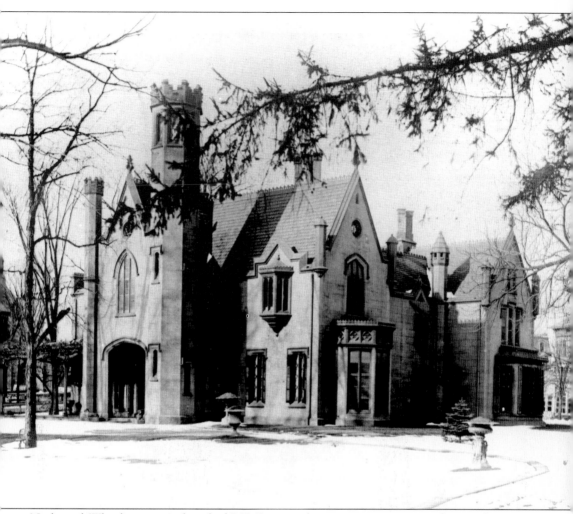

Nathaniel Wheeler, a great friend of P.T. Barnum, became a prominent resident in the city, buying the home formerly owned by Mayor Henry K. Harral on Golden Hill Street. The home was named "Walnut Wood" and was designed for Harral in 1845 by the foremost architect of the time, Alexander Jackson Davis, who also designed "Lyndhurst" in Tarrytown, New York.

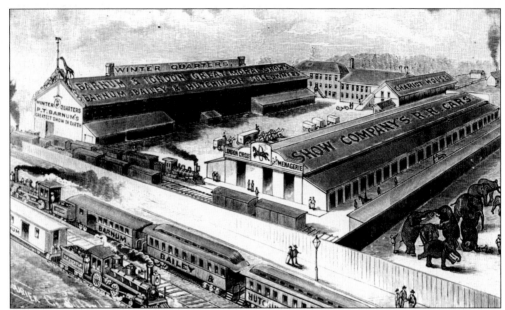

Elephants, along with other circus animals, were a common sight in Bridgeport's West End, due to the occupation of one man, circus showman P.T. Barnum. Barnum built the Winter Quarters in 1871 to house his newly established circus. Local Bridgeport residents got used to peeking over the fence at the circus animals and, once in a while, an animal would get loose in the area now known as Went Field—Norman Street, Wordin Avenue, Railroad Avenue, and Hanover Street. Local circus performers also wintered in the area and worked in Bridgeport factories. Shown are the Winter Quarters, as illustrated in P.T. Barnum's autobiography, *Struggles and Triumphs*.

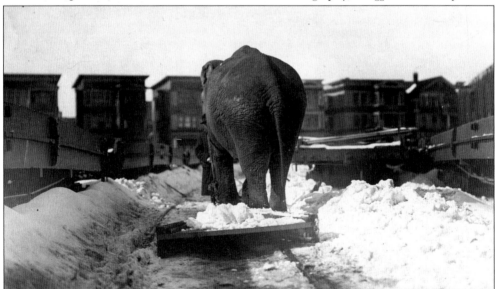

The 10-acre lot near the railroad tracks proved to be an excellent place for some automatic advertising for P.T. Barnum. Often the elephants were set to work plowing the area near the tracks. Travelers on the New York, New Haven & Hartford Railroad could see the animals from the train. Here, an elephant plows snow at the Winter Quarters. Notice the West End housing in the background.

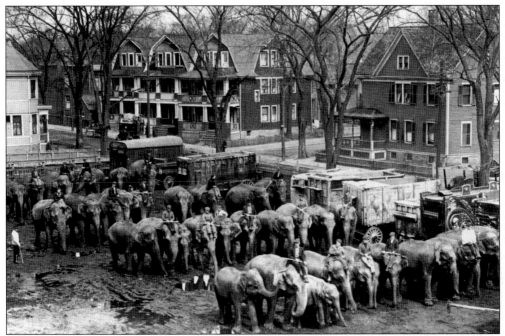

Imagine waking up one morning and seeing a herd of elephants outside your front door. If you lived in Bridgeport's West End in the years 1871 to 1927, you might not be dreaming. The Barnum and Bailey elephant trainers and circus workers corral the animals in the muddy field at the corner of Norman and Cottage Streets in the 1920s. Living in the area were circus performers, including Mabel Stark, who trained lion cubs in her basement.

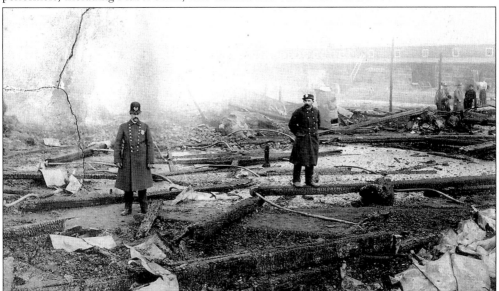

On the evening of November 20, 1887, the main animal building of the Winter Quarters caught on fire. Fire spread quickly, devouring the buildings in the lot and making it impossible for animals to escape. Elephants were the only animals from Barnum's Winter Quarters that managed to escape the flames. This photograph of the fire's aftermath shows the smoking ruins of the Bridgeport Winter Quarters. The Winter Quarters were rebuilt after the fire.

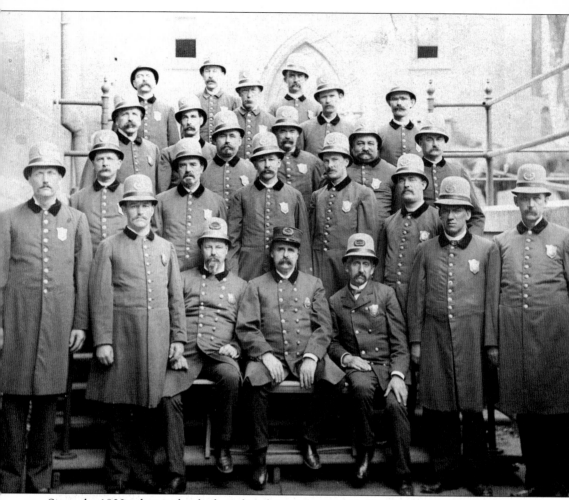

Since the 1800s, the city has had a police department, originally relying on volunteers to patrol the streets. The first chief of police was designated in 1869 and, by 1885, when this photograph was taken, the Bridgeport City Police Department was a full-fledged city department. According to the 1885 annual report for the police department, the most numerous cases were 153 charges of theft, 578 acts of drunkenness, 13 cases of fraud, and 110 cases of breach of peace. Police had reported other crimes such as Sunday ball playing, one case of carrying a deadly weapon, and two cases of killing ducks. One of the many duties of the police officers was the job of extinguishing gaslights in the streets.

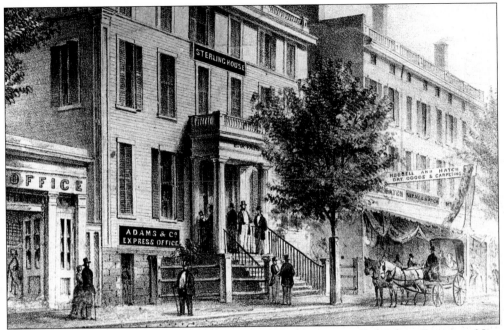

Alvin Adams, a Vermont native, started his own express business called Adams Express in New York City in 1840. When the U.S. Department of the Treasury contracted with Adams for the transportation of government funds and the New Haven and New York railroad lines grew, the Adams Express Company opened offices in Bridgeport in the Sterling House.

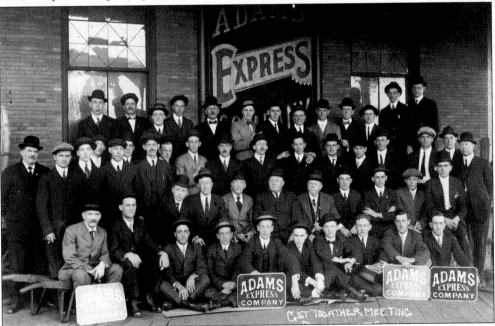

Henry Sanford of Bridgeport became president of the Adams Express Company. In 1861, Sanford and Allan Pinkerton were asked to escort Pres. Abraham Lincoln on a trip. Pinkerton later started the famous Pinkerton Detective Agency and often visited Sanford at his home on Washington Avenue. Adams Express Company employees gather for a photograph in 1914.

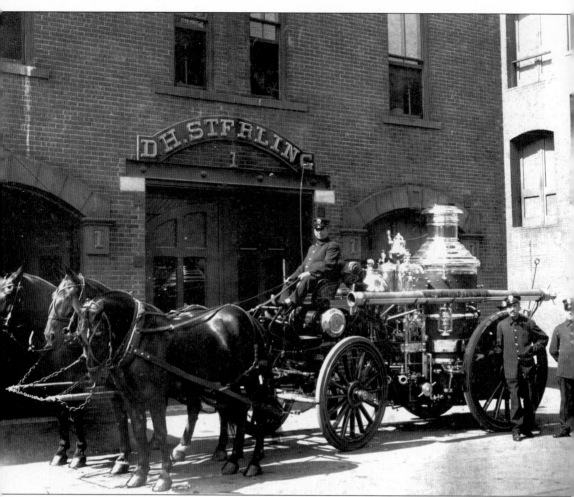

Even before Bridgeport became a city, a fire department of some sort existed. A bucket brigade, a volunteer effort of pulling water from the nearby Pequonnock River, was first used as early as 1796. Citizens had to own their own leather buckets and help others put out fires. This firehouse on John Street near Courtland Street was named for Daniel H. Sterling, Bridgeport's mayor from 1860 to 1862. This c. 1880 photograph shows the horse-drawn steamer, a thing of beauty—horses and steamer shined to perfection by hardworking firemen.

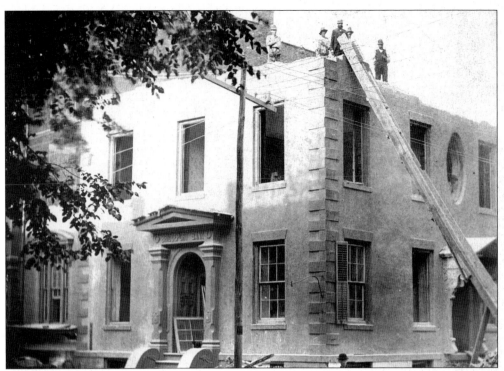

Wouldn't you know it? The earliest known photograph of Bridgeport is actually of a building being remodeled. The Bridgeport Bank (founded in 1806) was the first bank to obtain a charter in Fairfield County. This photograph of the building at Main and Bank Streets was taken in 1856.

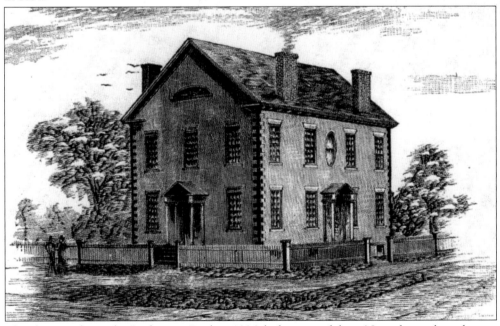

This drawing shows the Bridgeport Bank c. 1836, before remodeling. Note the oval window on the side of the building and the roof with smokestacks.

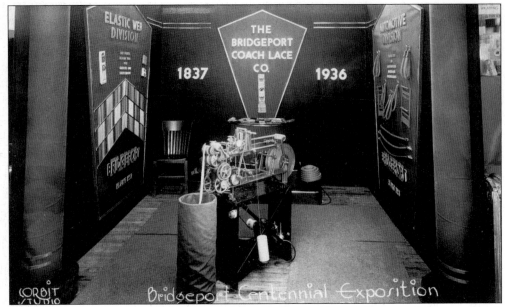

The materials used in Bridgeport industries that usually come to mind are metal, iron, and steel. However, in 1837, on John Street, an Englishman named Mills (first name unknown) began the Coach Lace Company, making fancy brocaded materials for the seats and interiors of carriages. This 1936 photograph of an industrial exhibit shows coach lace being made by machine.

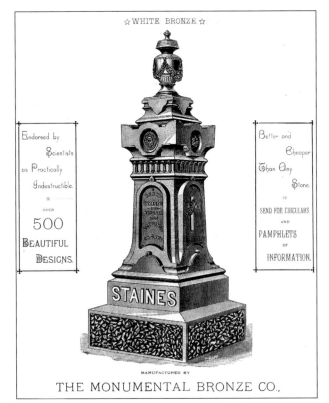

The use of white bronze for statues and tombstones made the Monumental Bronze Company famous. The zinc covering over bronze gave the artwork a luminous glow and made the objects even more indestructible, as shown in this 1888 advertisement. Even today, the gravestones and statues that were cast by the company have withstood the ravages of weather and are highly prized throughout the United States.

22

Owning a funeral parlor was a new business in late-19th-century Bridgeport. Local undertaker Louis Abriola recalled a huge funeral procession led by a band playing dirges, followed by 30 horse-drawn carriages and finally the funeral director driving a hearse. Not all funerals were that elaborate, but just as today, every ethnic group had its customs. Here, John Cullinan and Frederick C. Mullins, who normally buried people of Irish heritage, smile for the camera c. 1880.

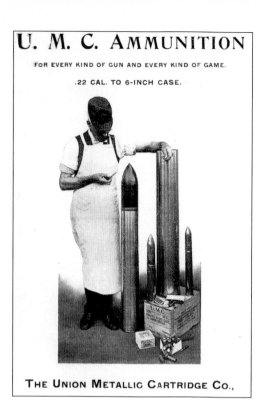

U. M. C. AMMUNITION

FOR EVERY KIND OF GUN AND EVERY KIND OF GAME.

.22 CAL. TO 6-INCH CASE.

THE UNION METALLIC CARTRIDGE CO.,

The Union Metallic Cartridge Company moved from New York in 1866, incorporating in 1867. This became the start of metal cartridge making in the United States, and the company sent cartridges all over the world. In 1873, when the rest of the United States suffered a financial panic, Union Metallic Cartridge was the only factory in Bridgeport that continued its regular output, providing employment for hundreds of Bridgeporters. The company was the forerunner of Remington Arms. An early advertisement has almost a "Barnumesque" quality in its depiction of a "Jumbo" cartridge, almost the size of a man.

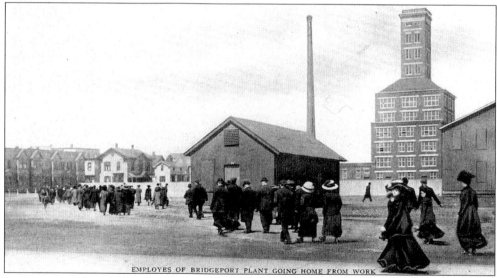

EMPLOYES OF BRIDGEPORT PLANT GOING HOME FROM WORK

As women and men in Victorian clothing walk home from their jobs at Union Metallic Cartridge in 1908, the Shot Tower stands as a towering fortress near the workers, a sharp contrast to the workers' height. It stood 167 feet high, larger than all of the other buildings on Bridgeport's East Side. The tower stands as a symbol of the beginning of the productive war years ahead.

Two
WORK

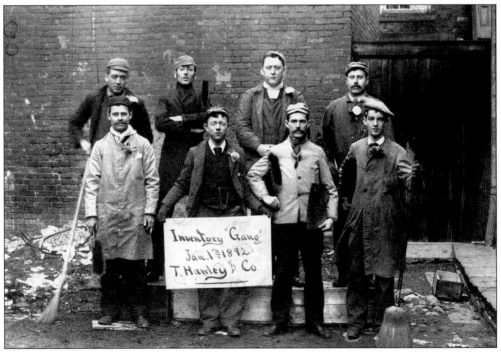

The inventory team of T. Hawley and Company celebrated the new year of 1892 by posing for a photograph. T. Hawley and Company, on Water Street, began in 1826 selling agricultural implements and building materials.

Young workers of the Buckingham Brewer Printers pose for a photograph c. 1900. First located on Middle Street, Buckingham Brewer Printers later moved to the second floor of the Post building, at 49 Cannon Street. The center boy looks about 12 years old. Children often worked in the factories and in other businesses before labor regulations were enacted in the early 20th century.

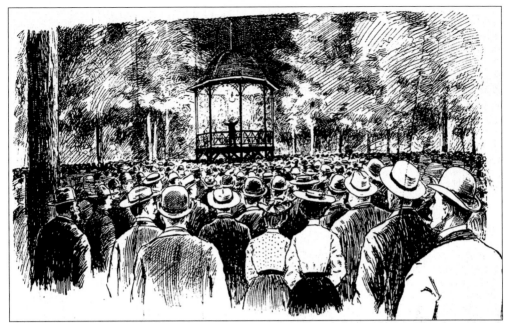

In May 1903, trolley workers at the Connecticut Railway and Lighting Company went on strike, asking for $2.25 per 10-hour day. Merchants and local businessmen, as well as other residents, were all affected by the transportation loss. In June 1903, an estimated 15,000 persons gathered at a mass meeting in Washington Park to support the striking trolley men. According to the *Bridgeport Sunday Herald*, "Men and women who toil for their daily bread in the factories and stores were there, thousands of them having walked miles to show by their attendance that they endorsed the action of the union trolley men."

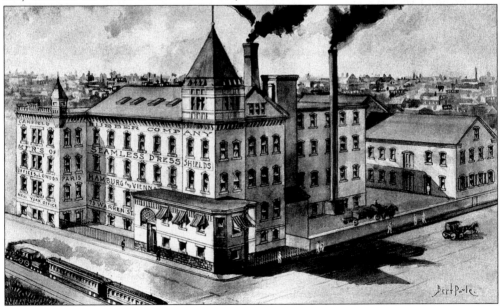

The Canfield Rubber Company, on Railroad Avenue near Myrtle Avenue, just a short distance from the Warner Corset Factory, is pictured in 1885. The company made rubber goods, specializing in seamless dress shields, a much needed item for women wearing heavy Victorian gowns.

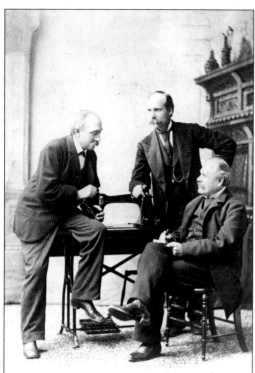

Wheeler and Wilson Sewing Machine Company engineers Matthew Dimond (on the machine) and Isaac Holden (in the chair), pose with inventor Aurelius Steward. The three men were responsible for innovative models created at Wheeler and Wilson.

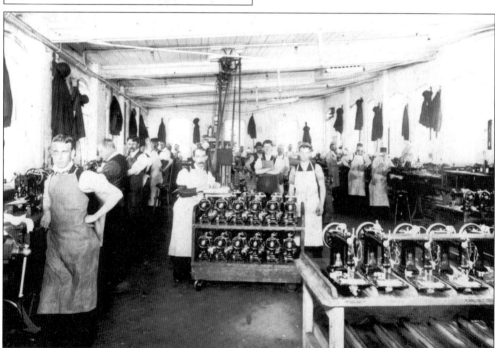

Workers at the Wheeler and Wilson Sewing Machine Company put in long hours for little pay. Workers often worked a 10-hour day at an average day's pay of $2.05. The man leaning on the sewing machine truck (left of center) is identified as local resident Andrew T. Eaton. The photograph was taken c. 1903.

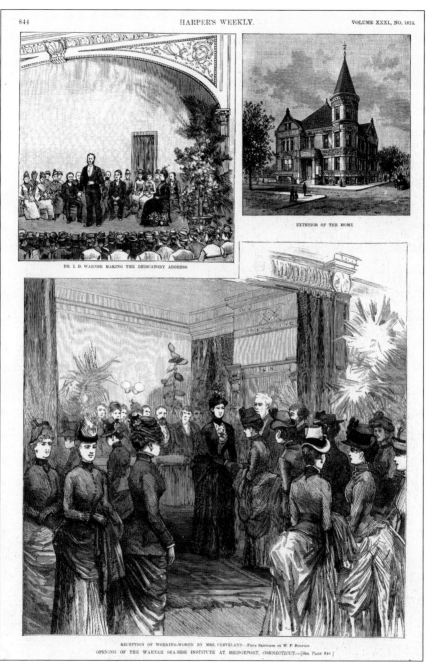

DR. I. D. WARNER MAKING THE DEDICATORY ADDRESS

EXTERIOR OF THE HOME

RECEPTION OF WORKING-WOMEN BY MRS. CLEVELAND.—FROM SKETCHES BY W. P. BODFISH.
OPENING OF THE WARNER SEA-SIDE INSTITUTE AT BRIDGEPORT, CONNECTICUT.—[SEE PAGE 846.]

Brothers Lucien C. Warner and I. DeVer Warner started their corset factory in 1876 in the city's South End, designing a "health" corset that became one of the favorite designs of women throughout the world. The factory became one of the largest employers of women in the world. Near the factory on November 5, 1887, the Warner brothers opened the Seaside Institute, a facility that was free to all Warner women employees. The institute had classrooms for instruction in bookkeeping, needlework, cooking, and drawing. It was the first facility of its kind in the United States. Shown here is the opening ceremony, which Mrs. Grover Cleveland attended.

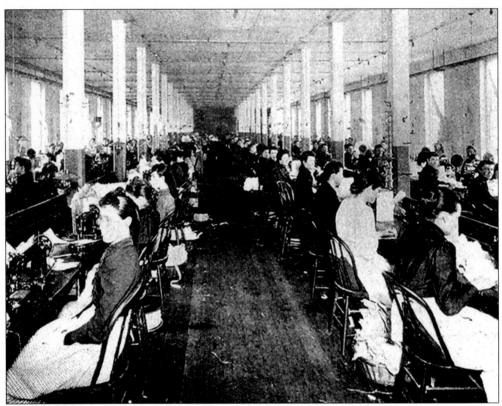

Women workers sew in the factory c. 1890. Note the uncomfortable wooden chairs in which the women had to sit for long hours.

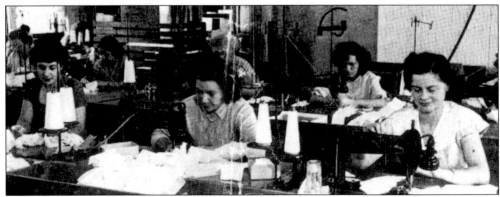

Warner Factory workers pictured in the April 1950 *Warner's Corset Box* newsletter look a bit more relaxed at their work than did their late-1800s predecessors. Pictured from left to right are Marie Jackel, Pauline Williams, Marie Vagnini, Anna Roske, Betty Zaletta, Anna Luchinski, Loretta Woznick, and Rose Kondray.

President, EDWARD R. IVES
Treasurer, HARRY C. IVES
Secretary, CHARLES H. SILLIMAN

IVES TOYS

Electric and Mechanical
Miniature Railways

The Ives Manufacturing Corporation
Bridgeport, Conn.

NEW YORK OFFICE: Room 432, Fifth Ave. Bldg., B'way, 23d St. and Fifth Ave.

In 1870, Edward Ives started his toy company in Bridgeport and built some of the finest clockwork toys on the market. In 1901, the toy manufacturer made mechanical trains that ran on tracks. Ives trains became very popular, and by 1907, the company opened a new factory on Holland Avenue in the West End. The company's slogan, "Ives Toys Make Happy Boys," was used in all its advertising and catalogs.

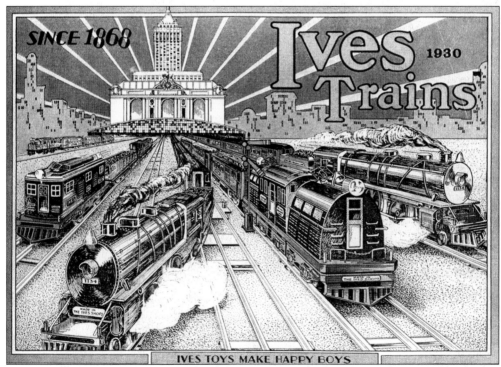

By the 1920s, competition from other toy train manufacturers such as Lionel, as well as an overly generous reputation for repairing broken trains for free, led to the company going into a financial slump, filing for bankruptcy in 1929. After selling to a competitor, the plant itself closed in 1932.

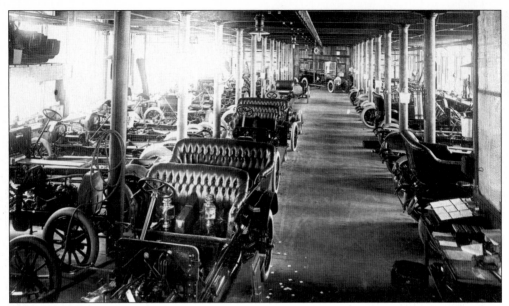

"The most modern and the most complete automobile plant in this country" is how advertisements described the Locomobile plant at the beginning of the 20th century. The company was founded in Newton, Massachusetts, in 1899 but soon after moved to Bridgeport at the foot of Main Street near Seaside Park. Here is a 1907 look at the inside of the factory.

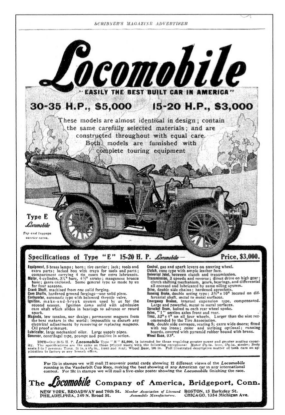

The Locomobile Company of America had a long career of building exceptionally fine and expensive automobiles. Known the world over, the Locomobile was "Easily the Best Built Car in America," as the company's slogan said.

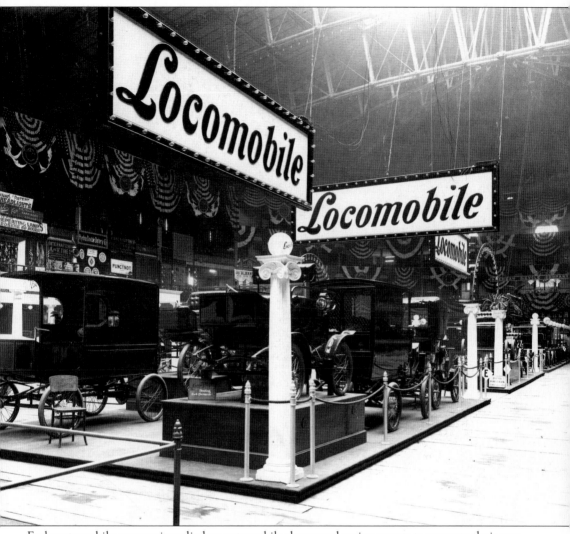

Early automobile companies relied on automobile shows and racing events to promote their cars and to get noticed by the public. This impressive display of Locomobile steamers was at the first New York Auto Show in 1901. More than 5,000 Locomobile steamers were built between 1899 and 1904.

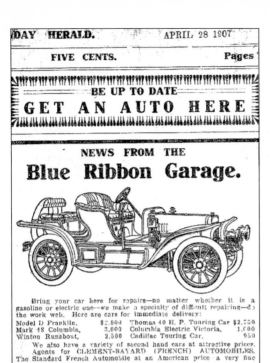

DAY HERALD. APRIL 28 1907

FIVE CENTS. Pages

══
══════════ BE UP TO DATE ══════════
GET AN AUTO HERE
══

NEWS FROM THE
Blue Ribbon Garage.

Bring your car here for repairs—no matter whether it is a gasoline or electric one—we make a specialty of difficult repairing—do the work well. Here are cars for immediate delivery:

Model D Franklin, $2,800 Thomas 40 H. P. Touring Car $2,750
Mark 48 Columbia, 3,000 Columbia Electric Victoria, 1,000
Winton Runabout, 2,500 Cadillac Touring Car, 950

We also have a variety of second hand cars at attractive prices. Agents for CLEMENT-BAYARD (FRENCH) AUTOMOBILES. The Standard French Automobile at an American price a very fine car.

The Blue Ribbon Horse & Carriage Co.

The automobile age brought new work to the city: selling cars and repairing cars. In 1906, Blue Ribbon Horse and Carriage Company on Cannon Street was renamed the Blue Ribbon Automobile and Garage Company, selling automobiles as seen here in a 1907 advertisement. Two years later, after it moved to its Fairfield Avenue site, the company expanded rapidly. Owners Johanas Schiott, a former Norwegian naval officer, and W.E. Seeley built the firm into the largest sales agency in New England. Branches of Blue Ribbon Garage opened throughout the state.

In 1912, the Blue Ribbon Garage supplied Pres. William Howard Taft with a Packard when he attended a Yale ceremony. The garage not only supplied automobile parts and made repairs, it also kept sleeping areas for chauffeurs. The garage even gave driving lessons. In 1914, the store became one of the first dealers to sell Dodge products. In 1929, when Chrysler bought out Dodge, the garage became a Dodge dealer exclusively. It closed in 1967.

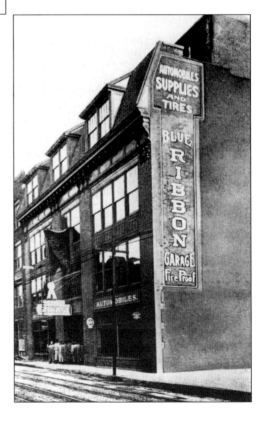

The Smith and Egge Manufacturing Company was started by F.W. Smith and his partner W.H. Day, making mail locks and keys. When sash chains were used in windows rather than cords, the company specialized in strong sash chains. Shown is an advertising page from an 1890s catalog.

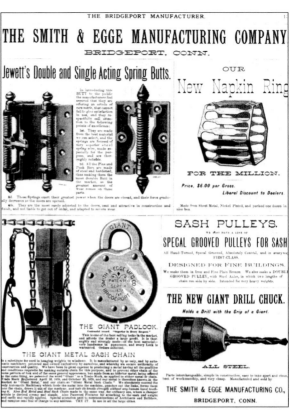

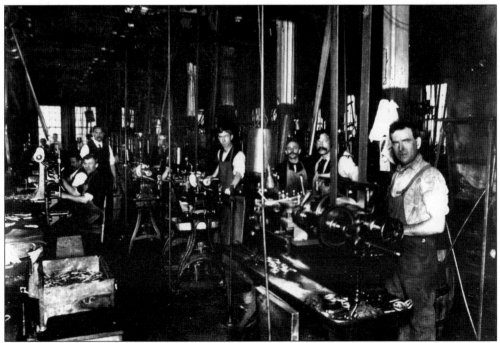

Inside the Smith and Egge Machine Shop, workers stop for the camera. Identified is Dennis Riley (right), uncle of the late local artist Bernard Riley, c. 1910.

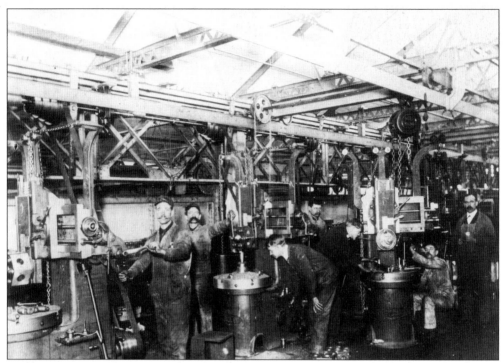

The factory floor of Bullard Machine and Tool Company was packed with employees when this photograph was taken in 1912. Founded in 1879 by Edward P. Bullard, the company became known for its turret lathes and other machine tools.

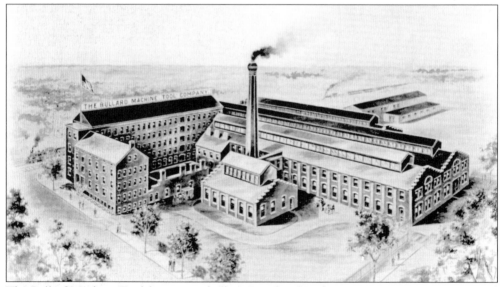

The Bullard Machine Tool factory was built at Broad and Railway Streets in 1892. It continued to enlarge until the buildings covered an entire block. In 1917, the company had 1,200 employees, which doubled in the years to come. In 1941, it leaped from maintaining a 1,200-person workforce to employing 6,500 workers on three shifts, in part to meet U.S. Navy defense contract demands for the precision assembly of torpedoes. Bullard eventually established plants in the city's South and West Ends and in the Black Rock section.

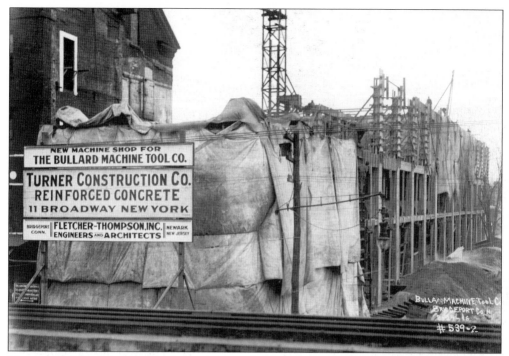

Not only the factories but also the businesses of architects and builders flourished during World War I as companies expanded. In February 1916, local architects Fletcher-Thompson designed a building constructed by Turner Construction for the expanding machine shop of the Bullard Machine Company.

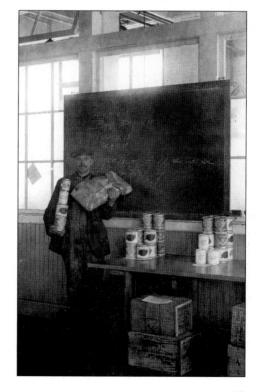

During the Depression years, canned and dried foods were sold at the Bullard factory. Many factories in the area provided cheaper food for their workers during the Depression years.

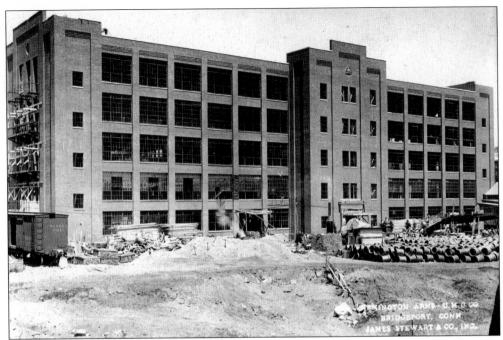

Taken in May 1915, this photograph shows the building site of what one year later was the among the busiest plants in Bridgeport's history: the Remington Arms and Union Metallic Company. The factory was built in a matter of months: in January 1915, the construction contract was given out; in March, ground was broken; and by November 21, enormous buildings had been completed.

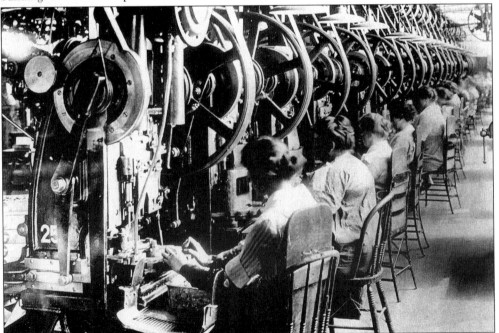

Remington Arms, along with many other Bridgeport factories, hired women during World War I. Here, a long line of women sits at the machines, making cartridges in 1915.

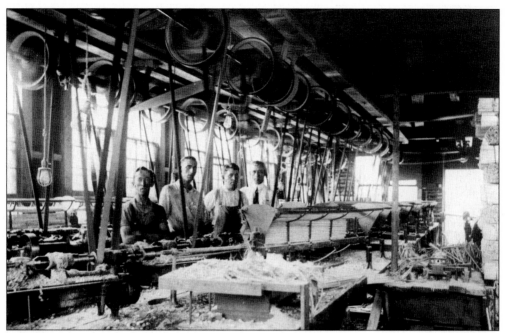

The Elmwood Button Company was located at 420 Poplar Street in the city's West End. Originally called the American Wood and Novelty Company, the business was purchased in 1903 by F.A. Persiani, who changed the name to Elmwood Button Company. Company workers made small wooden objects that were specially ordered by companies throughout the United States. The Milton Bradley Company ordered wooden pieces used for board games.

Bryant Electric was founded by Waldo Bryant in 1888. The company started in a small rented loft on John Street in downtown Bridgeport, with only eight workers. Eventually expanding and moving to State Street, Bryant became a subsidiary of Westinghouse Electric. The plant was one of the largest wiring device manufacturers in the world, employing 1,200 people. In 1928, 200 members of the Bridgeport Chamber of Commerce inspected the Bryant plant.

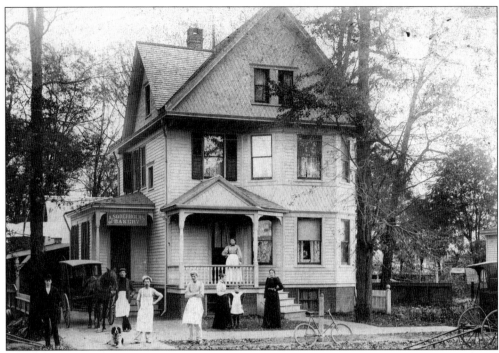

Swedish immigrant August Soderholm first opened a bakery with a partner, William McLemon, at 337 Hancock Avenue in the city's West End. By 1898, Soderholm had opened his own bakery on Maplewood Avenue, which became famous for its Swedish rye bread. The bakery also provided fresh coffee cakes, rolls, and other baked goods.

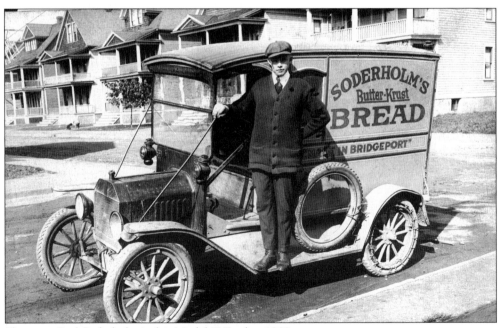

Shown is Carl Soderholm in his Model T Ford *c.* 1912.

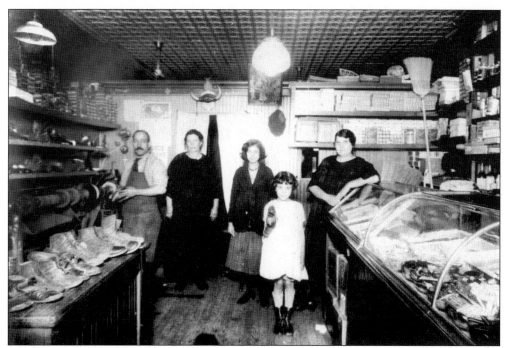

The Fiumara Shoe Repair Store, at 49 Sherman Street in Bridgeport's East Side, was run by the Fiumara family. Pasquale Fiumara was an Italian immigrant who learned the art of shoe repair. The family also operated a confectionery on the other side of the store. The photograph was taken *c.* 1925.

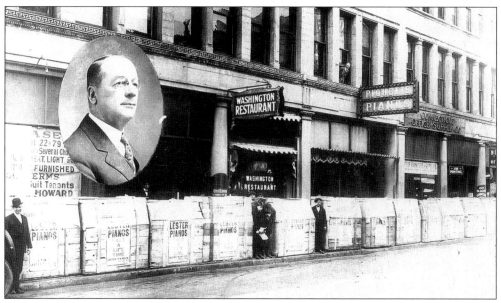

Pianos ready to be unpacked line Cannon Street in front of the Piquette Music Store. Henry Piquette opened his store in 1912, selling and tuning pianos. The store did a brisk business, selling sheet music, player pianos, and eventually other musical instruments. By 1938, the store stocked 2,500 copies of sheet music. Piquette's two sons, Joseph H. and William D., eventually took over the business.

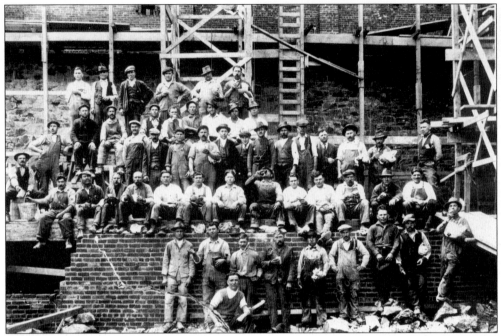

The construction crew from T.J. Pardy Construction Company takes a lunch break in 1922 while working on the Poli Theaters. The crew consisted mostly of Italian workers. The theaters, designed by architect Thomas Lamb, opened later that year.

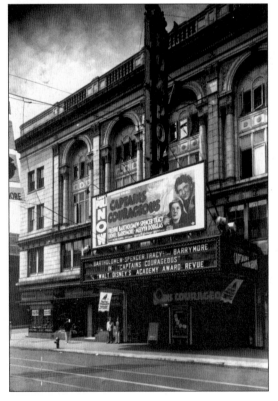

The 1922 opening of the Palace Theater was attended by hundreds of Bridgeport residents. The Majestic opened two months later, in November. A local newspaper cited the "superhuman efforts" by the workmen to finish the theater by the opening date.

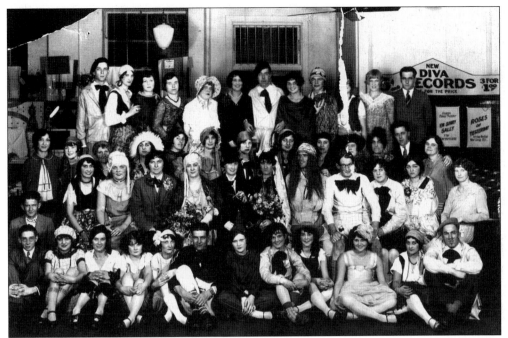

Chain stores were just beginning to catch on in 1909, when W.T. Grant opened the third store in his chain in Bridgeport. The store at 1189 Main Street became a popular place for Bridgeport residents to buy anything from shovels to jewelry, lampshades to magazines, and even clothing. Here, employees of the Main Street store dress up for an in-store masquerade party in 1928. Note the price of records on the wall, "3 for $1.09," with "Roses of Yesterday," by Irving Berlin, being advertised as the "new song hit."

Employees of the Bridgeport Shirt Factory, at 138 Hurd Avenue, have a picnic at Putnam Park, c. 1925. Factories like this were large employers of women, many of whom were new immigrants to the city.

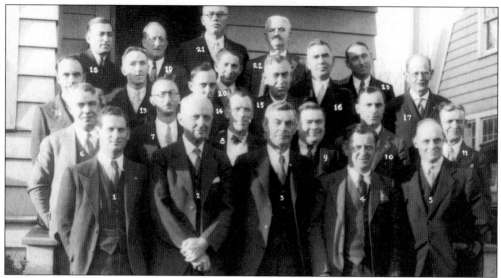

Politics in Bridgeport are always a sign of the times. Struggles with Republican and Democratic administrations of the past caused a complete change in Bridgeport's political views in 1933. The change was so drastic that Jasper McLevy, who had been campaigning unsuccessfully since 1911 as a Socialist, was finally elected the first Socialist mayor of Bridgeport. McLevy stands with his proud Socialist friends, Bridgeport's elected Socialist officials of 1933. Pictured are Jack C. Bergen (1), Richard Schulze (2), Jasper McLevy (3), Fred Schwarzkopf (4), John Shenton (5), William Hutton (6), William S. Neil (7), Charles Mottram (8), Harry Williamson (9), Angelo Canevari (10), Henry A. Costello (11), Andrew ? (12), James H. Kane (13), John M. Taft (14), Clifford A. Thompson (15), Meyer Zucker (16), Everett N. Perry (17), Isidor Kravetz (18), David Widdop (19), Kieve Liskofsky (20), George Puyda (21), Solomon Snow (22), and John B. Sheerin (23).

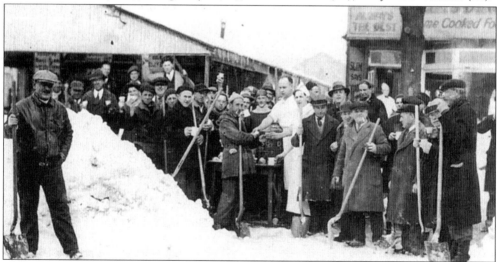

Edward "Slim" Young worked at local lunch counters until he opened his own diner at 372 State Street. In what was a former tire shop, he and his wife served food to 500 to 600 persons daily. His name became as popular as his diner. At six feet, three inches tall and 203 pounds, he answered to the name Slim and became part of the local color of downtown Bridgeport. After the fierce blizzard of 1934, he set up outside his diner on State Street and served coffee to the cold Works Progress Administration workers digging out the city.

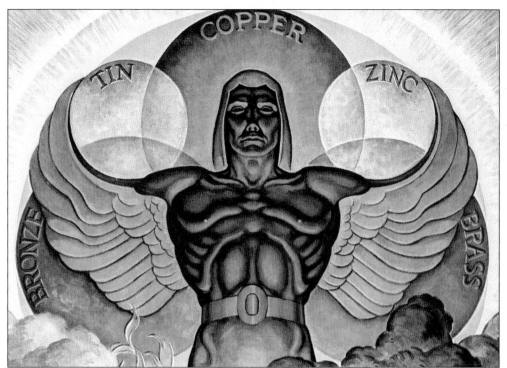

In 1944, Herbert Steinkraus, president of Bridgeport Brass Company, commissioned Robert L. Lamdin, Kerr Eby, and Ralph L. Boyer to create murals for his company. "The use of art to stimulate the production of war materials" is how one reporter described the efforts of the artists. Westport artist Robert L. Lamdin created *Brass through the Ages*, a portrayal of the vital role that copper, brass, and bronze have played in history. Depicted here is one of Lamdin's images, *Genesis of a Modern Metal*, from the mural.

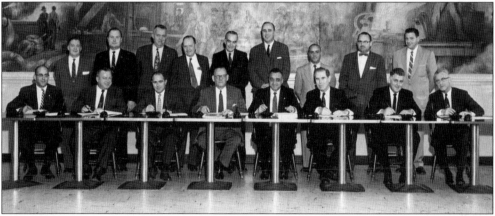

In the boardroom of Bridgeport Brass on October 17, 1956, the company and the Brass Workers Union No. 2411, AFL-CIO sign a labor contract. From left to right are the following: (front row) Frank Avalone, Frank Cunnane, Sam Volpe, Herman W. Steinkraus, Frank Mazzabufi, Joseph McNamara, Vincent Lattanzi, and Addison C. Thorton; (back row) Harold Dow, Gordon Sinclair, Reginald Yeomans, Alex Cashin, Daniel Hannon, William Grunnow, Sal Martire, William A. Jones, and Orlando LoRusso. Artist Robert L. Lamdin's murals of factory scenes form the backdrop.

The Bridgeport works of the Underwood Elliott Fisher Company in the South End employed 862 male and 250 female employees in 1935. Adding machines, bookkeeping machines, and other machines were produced in the plant, and parts for other operations were also built here.

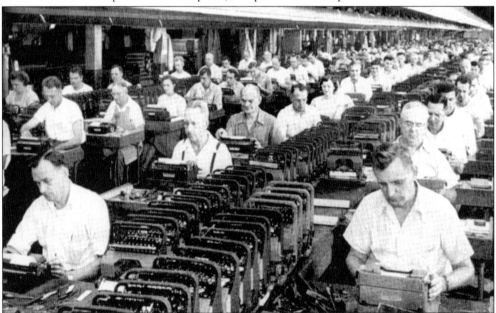

Final testing of the Underwood typewriters takes place inside the plant. All machines, including typewriters, were tested in assembly line fashion. This 1952 photograph shows men and women testing equipment.

The American Chain Company of Bridgeport was the largest manufacturer of chains in the world. Started in 1912, the company became known for its tire chains, which helped keep cars on the road in bad weather conditions. In the early days of tire manufacturing, use of these chains was essential.

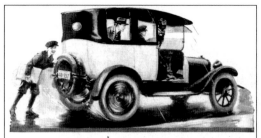

Plenty of Power but no Traction—spinning wheels that get nowhere

—and the man in the taxi believes he is paying for the futile spinning of the wheels. The meter on his car back home would register them in miles.

He believes the taximeter is registering a charge against him for the useless spinning of the rear wheels and the resulting damage to the tires.

A valuable object lesson, if it makes him think of his own car and how he abuses his own tires when he fails to put on

Weed Tire Chains
For Sure and Certain Traction

The taxicab companies protect the Public and themselves from skidding accidents—from excessive costs. *Taxicab wheels spin only when drivers disobey the companies' order to "Put on Tire Chains when streets are wet or slippery."* And to safeguard their patrons against the drivers' possible negligence, the taximeter is attached to *front* wheels.

Weed Tire Chains, when used judiciously, *lengthen the life of tires.* Whether they are used on taxicabs or on pleasure cars, Weed Tire Chains materially *reduce operating expenses.* Nothing looks more ridiculous than a spinning tire—nothing more brainlessly extravagant. Put on Weed Tire Chains "at the first drop of rain."

 AMERICAN CHAIN COMPANY, Inc.
BRIDGEPORT CONNECTICUT

In Canada: Dominion Chain Company, Limited, Niagara Falls, Ontario
Largest Chain Manufacturers in the World
The Complete Chain Line—All Types, All Sizes, All Finishes—From Plumbers' Safety Chain to Ships' Anchor Chain.
General Sales Office: Grand Central Terminal, New York City
District Sales Offices:
Boston Chicago Philadelphia Pittsburgh Portland, Ore. San Francisco

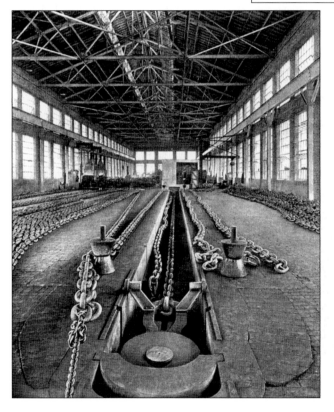

This is the end view of the testing machine at the American Chain Company, showing the chain in position ready for the strength test. A catalog published by the American Chain Company showed the variety of chains available—everything from cow ties, dog halters, and ship anchor chains to wagon, automobile, and tire chains.

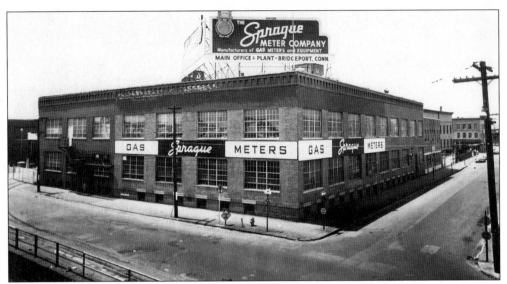

The Sprague Meter Company, at the corner of South Avenue and Water Street, employed around 250 people in 1975, a far cry from the two-room second-floor shop that opened at Fairfield and Water Streets in 1890, with Henry Sprague working as the proprietor and only five employees. About 100 cast-iron meters were made each week from the small shop. Henry Sprague developed a device that could accurately measure gas used in domestic and industrial environments. By 1940, the Sprague Meter Company manufactured over 1,000 gas meters a day.

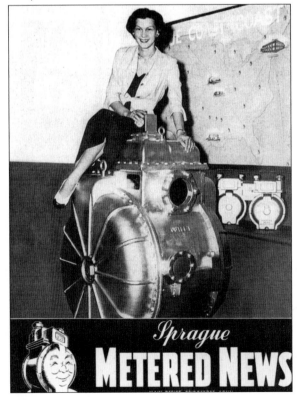

The August 18, 1950 issue of *Sprague Meter News* featured Sally Kozakewicz of the personnel department on its cover, sitting atop of one of the company's finer products. The newsletter was issued to Sprague workers and featured inside views of employee life, including employee articles about recent vacations, birthday listings, and even staff-produced poems.

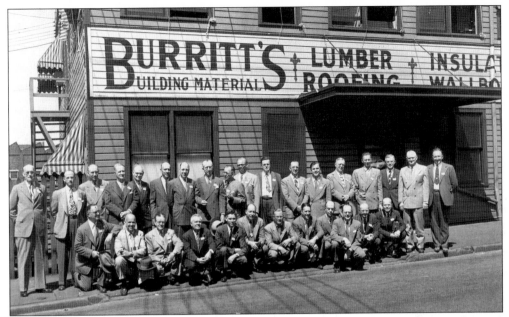

This 1949 photograph of the Burritt Lumber Company shows visiting lumbermen from 18 states. Arthur Clifford, company president, stands fifth from the left in the back row.

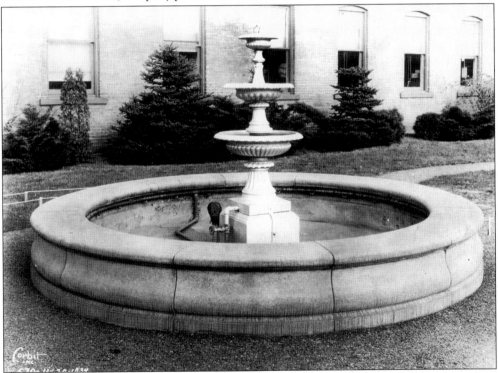

A familiar sight to people riding through Bridgeport by train was the fountain at the Jenkins Valve factory in the South End. The fountain was a 1934 gift to the city by Jenkins Brothers. In the city since 1864, Jenkins Brothers was one of the first factories in Bridgeport to adopt a five-day work week.

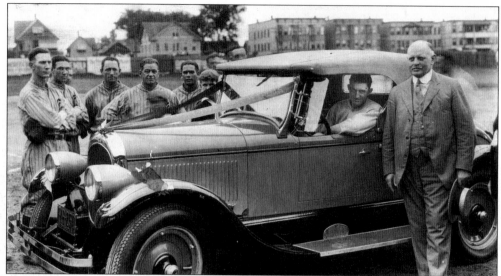

In 1941, the Bridgeport Bees started playing in Newfield Park. The professional minor-league squad played in the Colonial League. The Bees had several managers before Frank "Bud" Stapleton took on the job in 1950. Stapleton, who had previously managed other Bridgeport teams, stands next to his Chrysler with team members in Newfield Park on August 23, 1926.

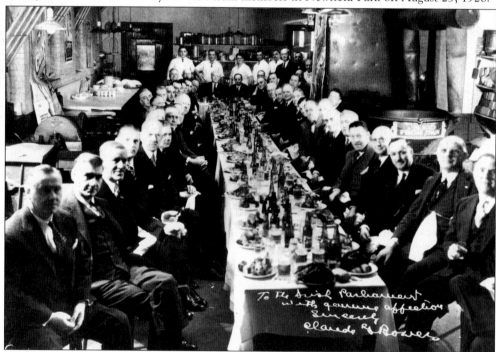

Bill Behrens opened a meat store in 1898. Behrens was mayor of Bridgeport from 1923 to 1929. He would often put on an apron and serve large meals to his friends, whom he collectively called the "Irish Parliament." Celebrities—such as Claude Bowers, former U.S. ambassador to Spain and Argentina and the U.S. postmaster general—often visited for these dinners. Here, Bowers and Bridgeport Times-Star publisher Jim McGovern (center, far back, with white hair) sit at one of Behrens's dinners in 1933.

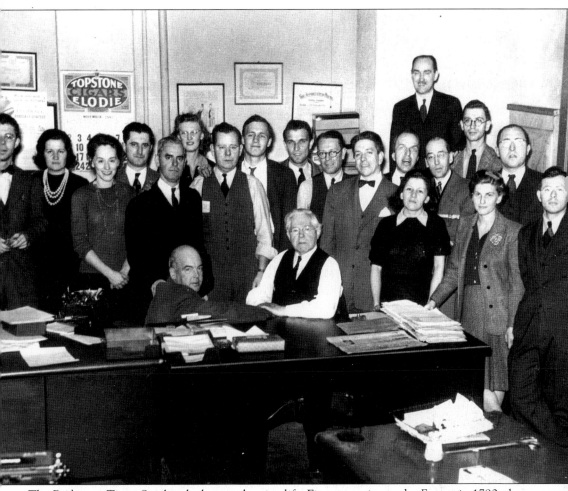

The *Bridgeport Times-Star* lived a long and active life. First appearing as the *Farmer* in 1790, the newspaper continued under various names and finally emerged as the *Bridgeport Times-Star* in 1926. The offices of the Times-Star were in the old Seaside Club on Lafayette Boulevard. James L. McGovern (center, seated right) was the editor of the paper. The newspaper was known for its honest and nonpartisan reporting of local labor and immigrant issues. This photograph of the employees of the Bridgeport Times-Star was taken on the newspaper's final day of publication, November 25, 1941. A purchase of the paper for $200,000 by the owner of the competing *Bridgeport Post* surprised employees of the Times-Star. Given 30 minutes to vacate the premises, the Bridgeport Post sent a special crew to demolish the Times-Star presses.

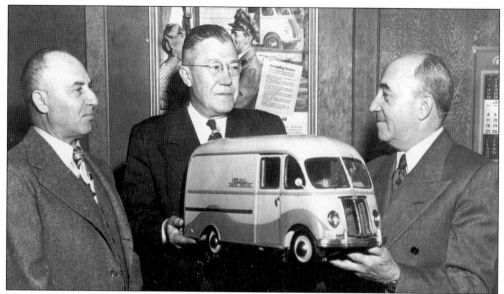

Philip Carlson (right) and his brother William Carlson (left) came to this country from Poland in 1905. After a short stint in New York, they traveled to Bridgeport, where Philip got a job at the Wheeler and Wilson Sewing Machine Factory and William got one at the Locomobile factory. In time, the brothers constructed a building on Grand Street and, there, they got their first big contract: Riker Trucks. The brothers show a model of a Metro Truck to William Schumacher (center) of International Harvester in 1948.

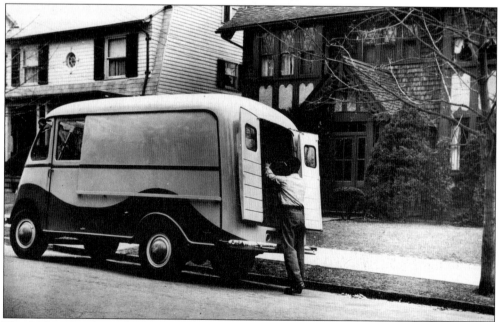

The Carlson Brothers all-steel Metro van was the answer to the delivery problems of many large retail stores, dairies, and milk companies. The Metro was a truck that the driver could easily step out of to make deliveries. It became popular throughout the United States as the most economical and efficient way of making local deliveries. This Metro Truck is parked in front of William Carlson's home on Crown Street.

Rudoph Bannow emigrated from Sweden to Bridgeport in 1915. As a young man, Bannow studied the pattern-making trade throughout New England. In 1929, he joined another Swedish immigrant, Magnus Wahlstrom, in the manufacture of high-speed milling attachments and machines. In 1939, after selling their pattern business, Bannow and Wahlstrom formed Bridgeport Machines.

Workers Fred Voytek and Dolores Manca inspect pencils at the Connecticut Pencil factory on Maple Street, 1952.

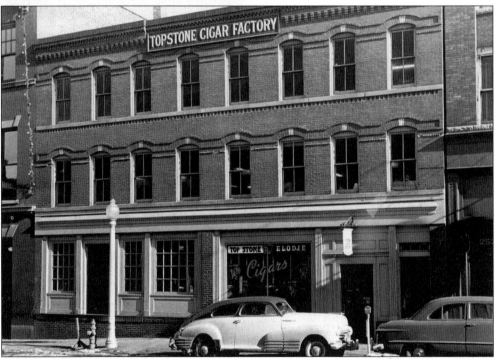

Like nothing else, the smell of a good cigar can bring back memories. In Bridgeport, the Top Stone Cigar Company, at 256 Middle Street, provided cigars for generations of local residents. Top Stone Cigar was founded in 1903 by Edward Waegemans, a Belgian immigrant. The company used machines to roll some cigars, but special cigars like the Felipe Suave were rolled by hand. The Bridgeport business closed in the late 1970s. However, Top Stone cigars—now made in Florida—are still available at cigar stores.

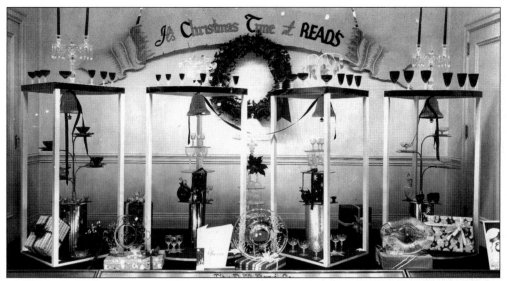

Retailers in downtown Bridgeport had fine store windows. The 1936 Christmas window of Read's Department Store on Broad Street displayed the latest in beautiful glassware, reflecting the art deco style of the times.

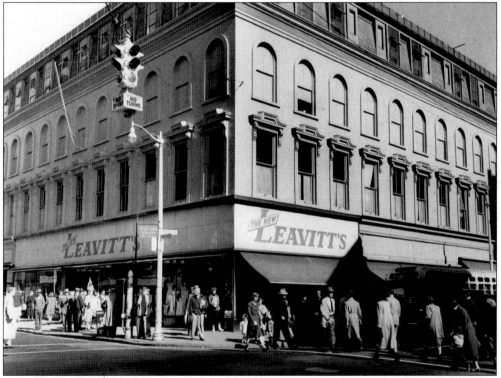

The corner of Main Street and Fairfield Avenue was a familiar site for Bridgeport shoppers looking for a bargain. Leavitt's department store opened in 1928, one year before the onset of the Great Depression. The store opened with fur-trimmed coats for $14.65, new women's hats for $1.85, and aprons for 39¢. The store was sold to Leo Federman in 1936, and it continued as Leavitt's for three more decades.

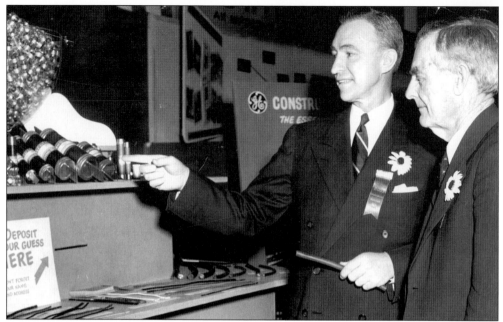

At a trade show on May 8, 1951, General Electric executive C.C. Walker (left) shows Mayor Jasper McLevy the latest G.E. products.

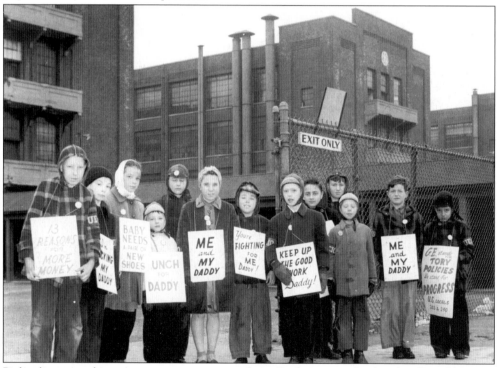

Picket lines were becoming a more common sight in Bridgeport as the decade of World War II ended. The 1946 strike against General Electric was a nationwide strike—even the children of Locals 203 and 240, United Electrical Workers got in line with signs that supported their parents. "You're Fighting for Me, Daddy!"

Three

BEEN WORKING
A LONG, LONG TIME

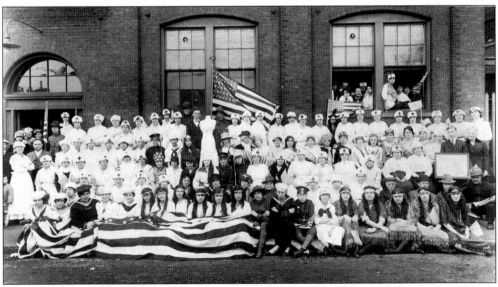

Edward W. Russell and William Batcheller founded the Crown Corset Company in Bridgeport in 1899. On April 13, 1917, the Crown Corset Company had a flag-raising ceremony in front of the factory on Railroad Avenue. Ceremonies like this were held throughout the city; on April 6, 1917, President Wilson had just declared war on Germany. Today, the Crown Corset Company is Crown Foundations and is located on Barnum Avenue.

Pembroke Shirt Manufactory.

O. E. LINDSLEY,

MANUFACTURER OF

Fine White Shirts and Drawers

Shirts made to Order and a perfect fit guaranteed.

FINE FRENCH FANCY SHIRTS AND SHIRTINGS ALWAYS IN STOCK.

Collars and Cuffs Laundried and Re-moulded equal to new; 20 to 30 hours notice required.

PERFECT FITTING SHIRTS.

Orlo Lindsley was the supervisor of the Judson Brothers Shirt factory, at 28 and 30 Fairfield Avenue. Lindsley took over ownership of the company in 1860, renamed the business Pembroke Custom Steam Laundry, and expanded the business to a custom steam laundry. This 1877 advertisement from a city directory offers "shirts made to order and a perfect fit guaranteed."

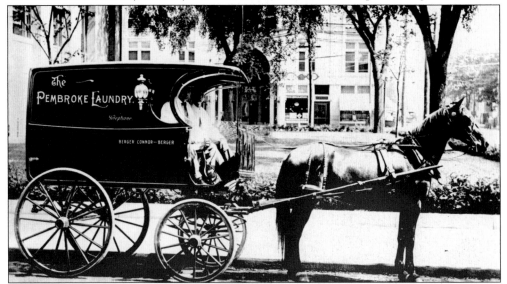

Orlo Lindsley advertised that families could have their clothes laundered "on short notice" and "where theatrical troupes and traveling men can get accommodated." The laundry was only a half-block from the train station. Pembroke Laundry is still in business today, on Madison Avenue in Bridgeport. The Minty family has owned Pembroke Laundry since 1917. Shown is a horse-drawn laundry truck near the old city hall, now McLevy Hall.

Rubber stamps, stencil machines, steel stamps—these are some of the goods that Schwerdtle Stamp Company has been selling to Bridgeport area customers since 1869. Louis and Edward Schwerdtle bought out the Bridgeport Stamp Company that year, and the family has run the business ever since. This is an engraving of the building at 39 Farfield Avenue that Schwerdtle Stamp occupied.

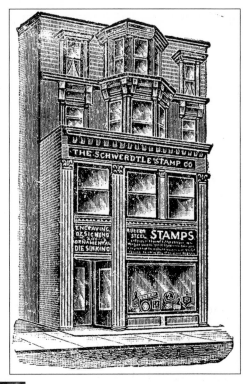

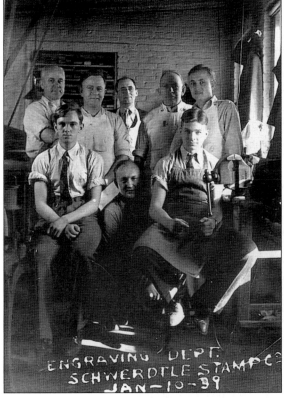

Workers at the Schwerdtle Stamp Company engraving department stop work to pose for a photograph on January 10, 1939.

The Post Building was erected on Cannon Street in 1892 and was first occupied by the Evening Post. The building was enlarged in 1901 and became offices of the Evening Post and the Morning Telegram-Union. In this series of photographs taken in the Cannon Street building in 1916, the hard work of running a daily newspaper is clearly depicted. Reporters in the city room of the Bridgeport Post check their stories in the first edition. On the wall in front of the man in the foreground is a wire basket on a pulley system that took completed pages of copy to the linotype department on the floor above.

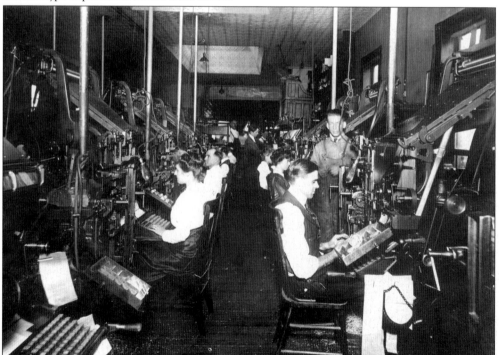

The linotype operator in the production department hand-typed all local wire and advertising copy. Linotype machines had the most moving parts of any machine. On occasion the molten lead alloy used to set the lines would squirt into the air, injuring operators.

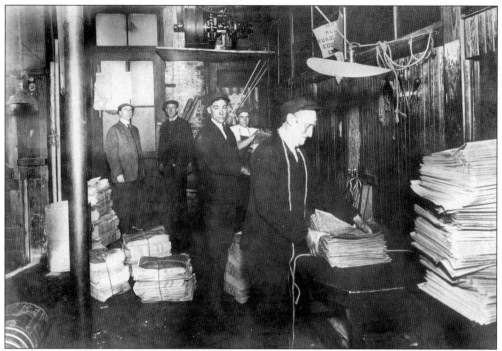

Pressmen scan the day's edition just off the rotary web press. Their duty was to check for inking irregularities and folio (page-heading) errors.

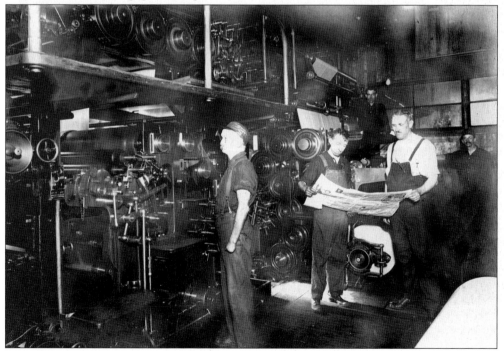

Hot off the press, newspapers are bundled, usually in stacks of 25, before they are distributed to newsboys and home delivery trucks. The process of removing papers from the press was called "flying" the press.

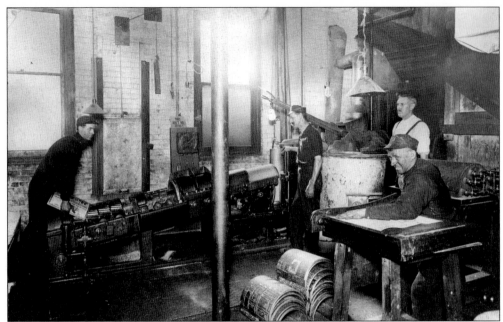

Workers called stereotypers make plates that will eventually be placed on the press. For many years, the stereotypers were the only unionized labor at the Bridgeport Post and Telegram.

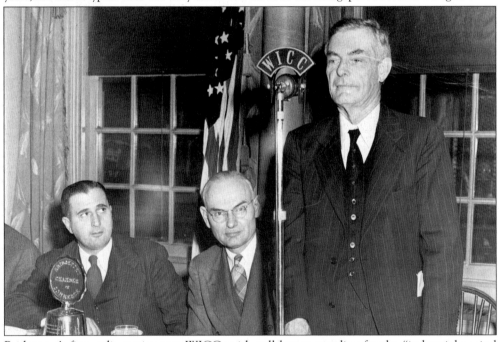

Bridgeport's first radio station was WICC, with call letters standing for the "industrial capital of Connecticut." It began broadcasting on November 16, 1926. Mayor Jasper McLevy was a regular guest on WICC, broadcasting radio addresses highlighting city activities. On November 18, 1947, McLevy (right) spoke in front of the Bridgeport Chamber of Commerce. With him is Arthur Clifford (center), president of Burritt Lumber Company, who served as the lumbermen's representative to the U.S. Chamber of Commerce.

Bartholomew Brignolo opened his photographic studio in the theater building on Congress and Main Streets in Bridgeport in 1912. He married May Smith in 1918 (shown here), and the couple ran the photography studio together. May Brignolo had learned the art of retouching in Nottingham, England.

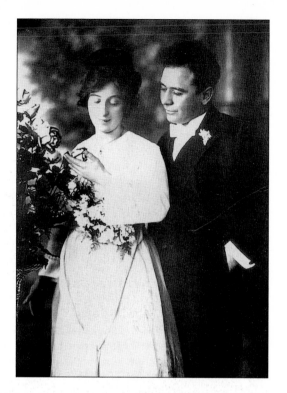

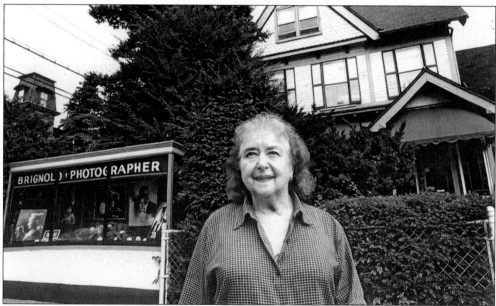

In 1927, when the rent was raised on the theater building and parking became more difficult, the Brignolo family moved to 632 Kossuth Street, at the corner of Barnum Avenue directly across from Washington Park. After Bartholomew and May Brignolo retired, daughter Ann Brignolo Hourcle (pictured in front of the house) and her husband, Laurent P. Hourcle, ran the studio together for 30 years. The daughter continues to run the studio today and has done so alone since her husband's death. The year 2002 marked the 90th anniversary of Brignolo Studios.

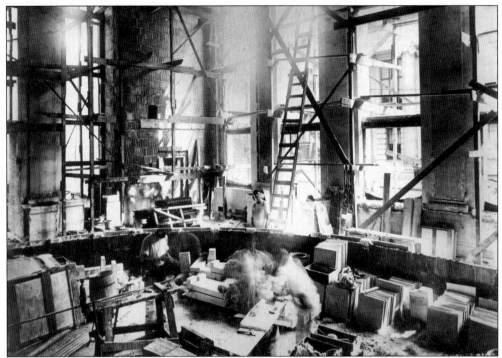

The 1917 building on the corner of State and Main Streets was designed by Cass Gilbert for the Bridgeport Savings Bank, which later merged into what is now People's Bank. The building was built with Vermont Imperial Danby marble and limestone. Bridgeport Savings Bank and People's Bank merged in 1926 to become Bridgeport People's Savings Bank. The 1917 bank structure is now home to Roberto's, a popular Italian restaurant. In this photograph, workers are busy completing the inside details of the structure.

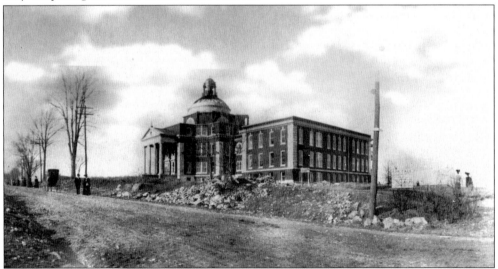

St. Vincent's Hospital stood alone on upper Main Street when it opened its doors on June 28, 1905. Looking like a fortress on the empty road, the new building had three floors and a roof garden. It was located on the site of the old Hawley farm, which was purchased by Fr. James B. Nihill after a parishioner at St. Patrick's Church willed $14,000 to be used for a new hospital.

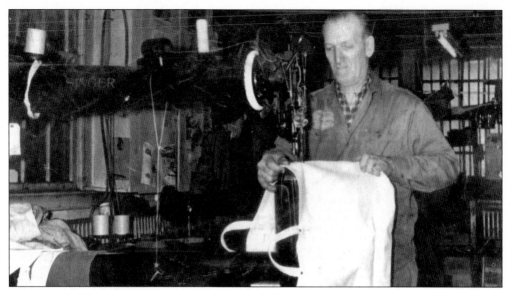

It was a simple idea: make a sturdy bag out of canvas fabric, and the bag will last forever. Josephson Bag Company has been a thriving business in Bridgeport since 1922. Charles Smith and Harry Josephson opened a factory at 1225 Seaview Avenue to make canvas bags for coal and ice deliveries. The company moved to Main Street in the city's South End. The factory started to manufacture other items, such as tote bags, bank moneybags, and tarpaulins. During World War II, the company made truck tarpaulins and other products needed by the U.S. military. Here, a worker sews a canvas bag on a huge Singer sewing machine.

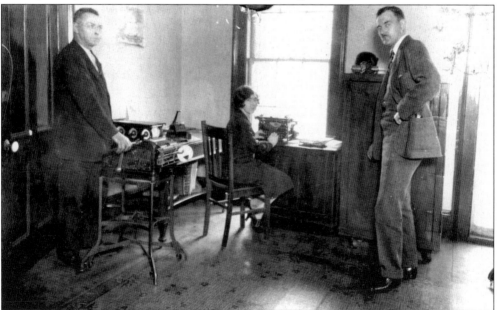

Both men and women worked in the Josephson Bag Company factory. Shown at her typewriter c. 1927, Elizabeth Josephson started working in the family business that year as a secretary. Eventually, she helped manage the business, went on to become company president in 1968, and retired at the age of 79 in 1987. The company was sold and has now moved to Cherry Street in the city's West End.

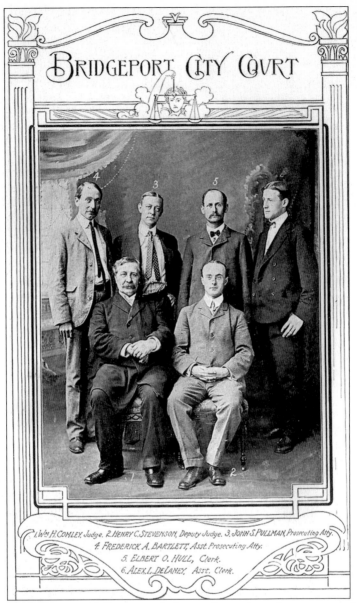

BRIDGEPORT CITY COURT

1. Wm. H. COMLEY, Judge. 2. HENRY C. STEVENSON, Deputy Judge. 3. JOHN S. PULLMAN, Prosecuting Atty.
4. FREDERICK A. BARTLETT, Asst. Prosecuting Atty.
5. ELBERT O. HULL, Clerk.
6. ALEX. L. DELANEY, Asst. Clerk.

The Bridgeport City Court in 1903 consisted of several prominent lawyers, two of whose names are still prominent in the city of Bridgeport today. John S. Pullman, prosecuting attorney (standing, second from left), started a firm in 1919 with the son of William H. Comley Sr. (seated, left). Pullman, whose father was a minister from Belfast, Ireland, was born in New Haven in 1871 and graduated from Wesleyan and later Yale Law School in 1892. A vice president of People's Bank, he died in 1943. William H. Comley Jr., a native of Bridgeport, first worked as a lawyer with his father in the firm of Comley and Comley. Young Comley was a quiet, soft-spoken person, who pushed sweeping drives against crime, particularly while serving as state's attorney for Fairfield County from 1924 to 1937. During the era of Prohibition, he waged war against rumrunners. He won prestige in several cases, including the famous Frank Palka trial. He died in 1955. The firm of Pullman and Comley is still located on Main Street in Bridgeport.

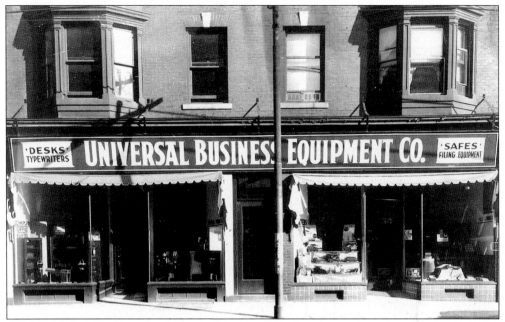

When Benjamin Factor opened the Universal Business Equipment Corporation in 1930, its first inventory was the office furniture of the bankrupt Locomobile Corporation. Shown here in 1936, Universal Business Equipment now occupies its own building and is the only remaining independent office product dealer in Bridgeport.

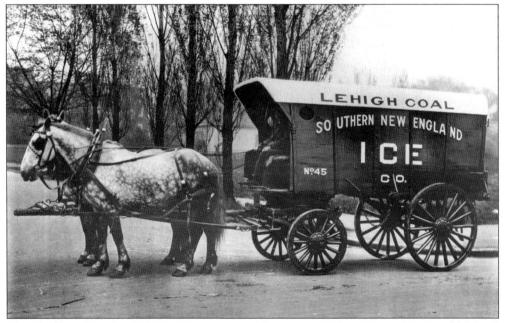

The Southern New England Ice Company would cut ice on Bunnell's pond in Beardsley Park during the winter and peddle it from house to house in a horse-drawn wagon. In 1929, more than 60,000 tons of ice were harvested from the Beardsley Park pond and were then stored in the icehouse. Eventually, the Southern New England Ice Company began manufacturing ice in a Knowlton Street plant, where it still manufactures tons of ice per day.

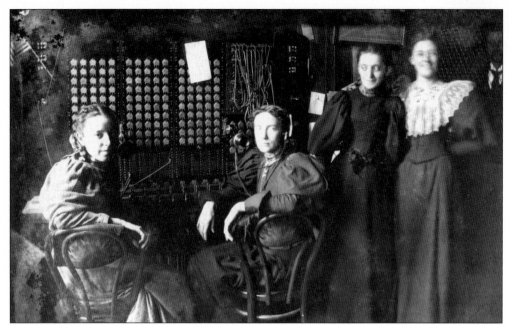

Ruth, Bessie, and Mabel E. Brague are shown at the Southern New England Telephone Company in 1903. The photograph was taken by Louis J. Brague, their father, who also worked for the telephone company. At that time, the Southern New England Telephone Company was housed in rented quarters on the second floor of the Farmers Building, at 179 Fairfield Avenue.

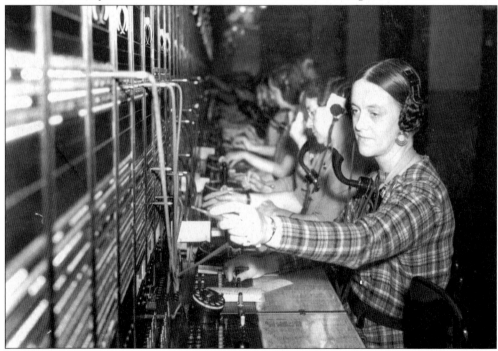

The Southern New England Telephone Company formed in 1882, moving to several locations before settling in its art deco building of 1930 at John and Courtland Streets. Here, a young operator takes a call in 1935.

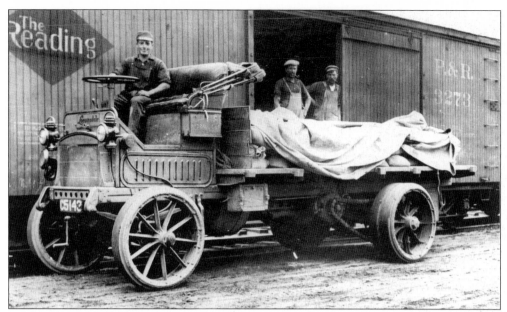

Employees of the Bridgeport Hydraulic Company use a Locomobile truck *c.* 1912 to make deliveries of sandbags. Bridgeport Hydraulic was founded in 1857. P.T. Barnum served as the company president in 1877.

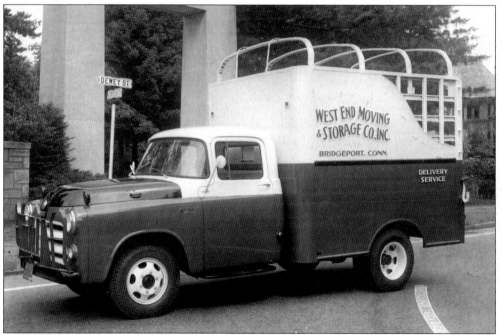

Russian immigrant John Kartovsky came to the United States in 1913 and worked at the Crane Company on South Avenue for 14 years. Kartovsky left Crane's employment, bought a truck, and began the West End Moving Company on Howard Avenue in 1927. His first truck carried household goods as far west as Chicago. By 1947, his business expanded to 10 trucks and two more storage facilities. A West End Moving and Storage truck sits in front of the Swan Memorial Gate at Mountain Grove on June 14, 1955.

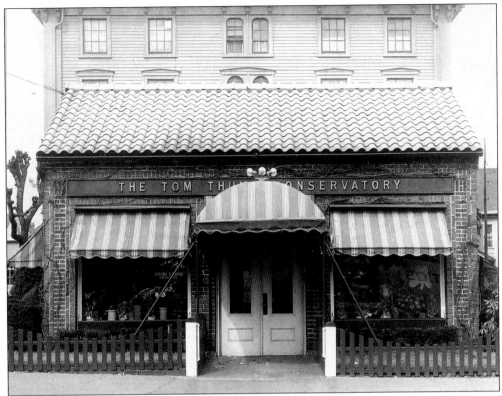

Florist William H. Hogan built the Tom Thumb Conservatory in 1923 in front of the home of Tom Thumb, at 956 North Avenue in the city's North End. Hogan sold bunches of violets to students heading to football games past the North Avenue store. In the 1920s, Hogan sold as many as 25,000 bunches of violets before a Saturday game.

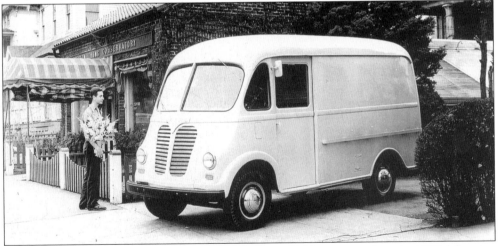

Joseph Padua worked in the flower shop with William H. Hogan, seen here in 1950 delivering flowers with a Carlson truck. In 1954, when Hogan retired, Padua continued the business. In 1963, he moved the business to 866 North Avenue. The Tom Thumb house itself was demolished in 1960 when City Trust expanded its parking area. The Padua family still runs Tom Thumb Florist.

70

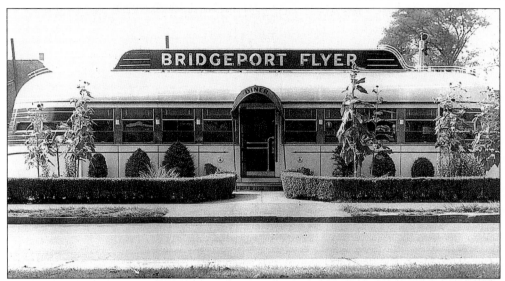

Antonios J. Rountos emigrated from Greece, first living in New York City and finally settling in Bridgeport in 1941 because of a business opportunity. The West Side Bank gave Rountos an option to buy land on Fairfield Avenue, at the time an area covered with trees and pleasant greenery, reminiscent of his Greek homeland. An art deco, streamlined diner was brought in from Massachusetts and placed on the lot. Rountos opened the Bridgeport Flyer Diner and catered to the nearby factory workers and travelers on trips from New York to Boston—in the days before the expressway was built.

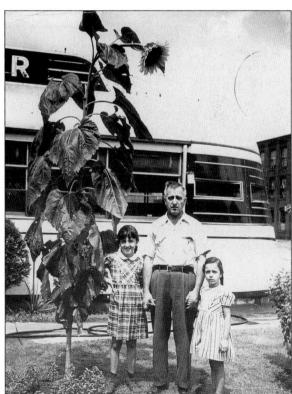

Pictured c. 1950 is Bridgeport Flyer Diner owner Antonios J. Rountos with his two daughters, Zoy (left) and Esther. The diner is still open today on the same site, run by the same family.

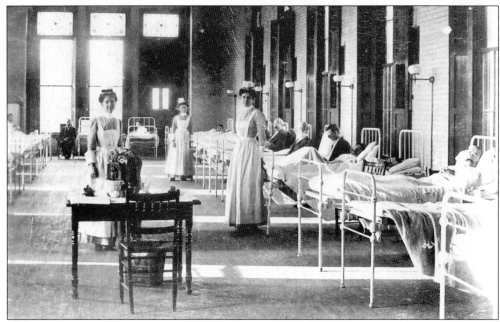

Bridgeport Hospital, completed in 1884 on Grant Street, was one of the most modern hospital buildings in the country. Designed by architects Lambert & Bunnell, the hospital was a pet project of P.T. Barnum, who became the president of the first board of directors of the hospital. The board of directors named Catherine Pettengill, Susan Hubbell, and Frances Elizabeth Pomeroy as founders of the hospital, due to the large endowment the women had contributed to the establishment. The final cost of the construction of the hospital was $120,508. Shown is the east ward of the hospital *c*. 1890.

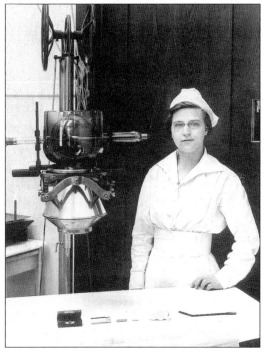

Dagmar Baggar was among the hospital's first x-ray technicians. X-ray was a brand-new field, and Bridgeport Hospital was a pioneer in that field. The x-ray equipment was kept in an area called sterile goods.

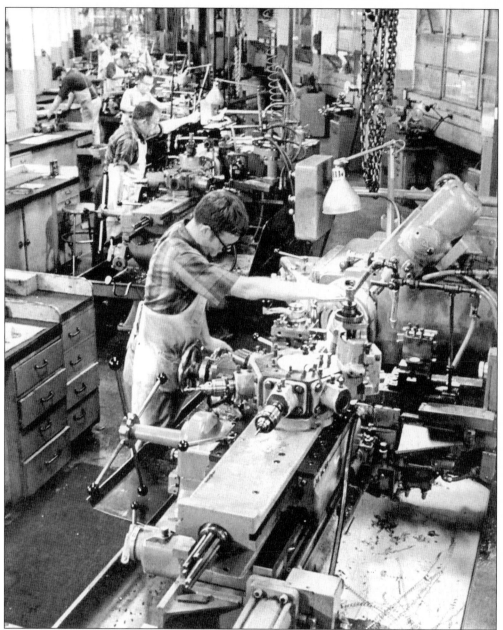

Starting with only two employees, Dick Moore opened a small tool company in Bridgeport in 1924. It proved to be an excellent idea, as Moore was soon supplying tools for Jenkins Brothers, Underwood, Locomobile, Dictaphone, and other Bridgeport companies. Besides supplying tools, Moore Special Tool set up machinery and built benches for workers. By 1930, the company had become a corporation and had begun building efficient and more accurate machines such as jig borers and jig grinders. In 1937, during the Depression, the company had 47 employees and actually expanded its production space in a building on Union Avenue. By 1967, the company had built a 40,000-square-foot plant on Union Avenue. Wayne R. Moore succeeded his father as president in 1974. The company now uses computer-controlled instrument panels on its jig grinder and other precise measurement tools.

CASCO
REG. U.S. PAT. OFF.
THE MOTORIST'S SAFETY MATCH

Patent No. 1710348 Patent No. 1710531
Other Patents Pending

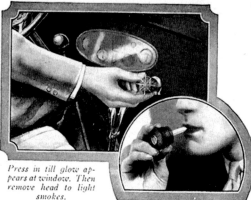

Press in till glow appears at window. Then remove head to light smokes.

The VISOLITE
CASCO No. 530
WIRELESS

This new CASCO presentation is something entirely new, different, and superior to any former development in cigar lighters for automobiles. The lens in the head shows when the unit is hot and ready to light cigar or cigarette. No danger of overheating. Prevents withdrawal before unit is hot.

The unit, being in a recess, heats more quickly and holds the heat longer.

The appearance of the genuine Bakelite head with nickel trim is unique and attractive. The action is perfect—just press in till red glow shows through the lens, remove head, and pass around. Heat lasts for several lights.

This new CASCO sells itself. Use the live counter display shown on page 6, which is furnished free to dealers.

530D For Mounting Through Instrument Panel

530 For Wood or Metal Instrument Panel

LIST PRICE $1.75
DEALER'S NET PRICE, 10 or more 1.05
Less than 10 1.22

Standard package 10. Weight 4 lbs.

REPLACEMENT PARTS FOR No. 530

	Part No. for 2-Piece Element Holder	Part No. for 1-Piece Element Holder	Price
Heating Element	No. 53	No. 48	$.50
Switch Assembly			
For No. 530	No. 530-7	No. 480-25	1.50
For No. 530D	No. 530-15	No. 480-26	1.50
For No. 530A	No. 530-7A	No. 480-28	1.50
For No. 530B	No. 530-23	No. 480-27	1.50
Heating Element Holder		No. 530-4	
Upper Half	No. 531		.65
Lower Half	No. 532		.30
			.25
Heating Element Gasket	No. 6093	None	.05
Heating Element Holder			
Complete	No. 530-1	No. 530-35	1.00

530A Special for Ford Model A
For Buick order 530B with Special Bracket

CASCO PRODUCTS CORPORATION

Connecticut Automotive Specialties Company (CASCO) was started in 1929 by Joseph H. Cone. Casco made brake-handle extensions and cigarette lighters, which were found in automobiles around the world. Casco Products was located on Hancock Avenue in the West End, moving in 1994 to the Horace Street location.

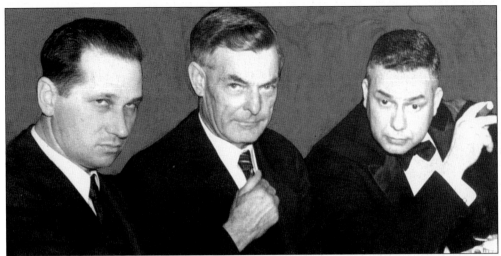

During the Depression, Alfred Bodine took over the bankrupt Anderson die machine company with several Anderson employees and started the Bodine Company in 1933. The model 40-10 tapping and screw-inserting machine designed by Anderson became the first standard product of the corporation. After a move from Iranistan Avenue to Fairfield Avenue, the company acquired the Springfield Manufacturing Building in 1936, and the company has been located at 317 Mountain Grove Street ever since. In this March 8, 1940 photograph, Bodine (right), company president, acted as toastmaster at a banquet of the American Society of Tool Engineers at the Stratfield Hotel. Mayor Jasper McLevy (center) and Gustave Samuelson of the Bridgeport Board of Education (left) drink tea together.

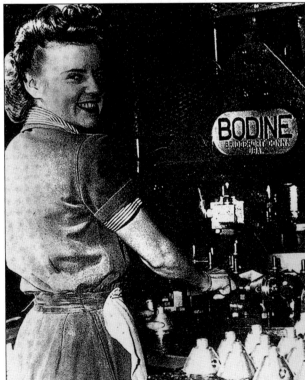

Hundreds of women worked in the factory during World War II producing military fuses on Bodine drilling machines. Anna Buzon stands on a production line using a Bodine machine at the Casco plant, making fuses for mortars and oil bombs. She won national attention as the "Most Typical War Worker" in the country in June 1945. Among the reasons that the judges picked her was that "she has been doing a war job since Pearl Harbor" and that she "left her job as a bus girl in Scranton to take a war job in a critical area."

Button, button, who's got the button? Davidson's Fabric Store. Even today, the basement of Davidson's is lined with buttons from an era of long ago, some that look like they are from 1939, when the store on Main Street opened. In 1935, Elias Davidson set up his fabric shop, buying some of the best fabric available on the market. By 1939, Davidson had retired and Marshall Lewis opened a larger store at 1192 Main Street. Women flocked to the opening; demonstrations of the latest fashions and sewing tips were given inside the store.

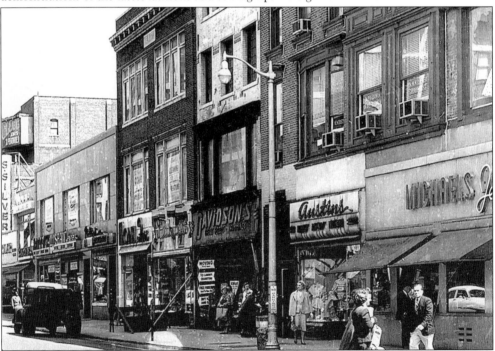

Davidson's Fabric Store moved to its present location at 1242 Main Street in 1956. In 1989, Marshall Lewis's son, Lance Lewis, took over ownership of the store. Shown is Davidson's in 1956 on Main Street, just before the move. Note the signs in the window.

Harvey Hubbell II opened his manufacturing facility in a small loft on Middle Street in Bridgeport in 1888. Although he had some early successes in manufacturing, it was his new pull socket, patented in 1896, that brought his real success.

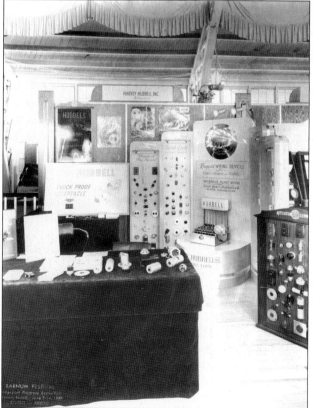

The Hubbell pull socket became a trademark, as well as a very successful product. The large electric sign on the roof of the Hubbell building was clearly visible to automobiles traveling along the highway. Here an incredible display of Hubbell products was on array in a 1949 Barnum Festival exposition at Pleasure Beach.

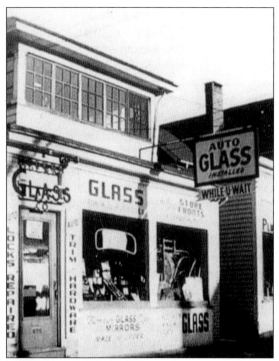

In a two-car garage near Howard Avenue, Joseph Carbone, first working with his brother in-law, founded the firm that specialized in automotive glass and "a little" plastic. Modern Plastics and Glass was born. Joseph Carbone was extremely interested in plastics and, by the 1960s, had built a larger plant on Howard Avenue in the city's West End. A small retail store was opened in the little shop on Howard Avenue, where plastic goods such as cutting boards could be purchased. Today, the company is family run, with the third generation of Carbones in a growing business.

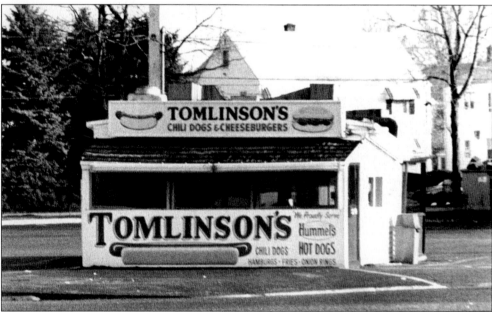

Platon Vlamis bought the hot dog business that was on the corner of Boston and Noble Avenues in 1949, keeping the old hot dog stand and the name Tomlinson for the business. Virtually just a shack with a grill inside and no seating, Tomlinson's had customers lining up outside the doors to have a chili dog or burger hot off the grill. The stand became a landmark where many a quick lunch was grabbed and by which directions were given. Many Bridgeporters could not pass by the corner without stopping for a "dog." The old stand was torn down in 2000, but a new, larger building with seating is currently on the same corner.

Four
FIRST IN BRIDGEPORT

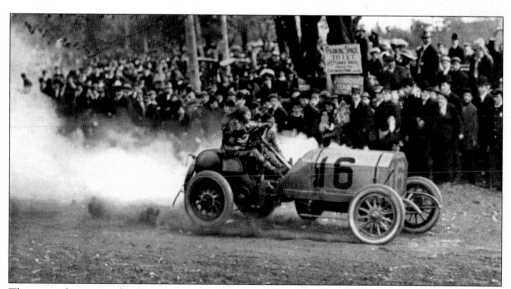

The most famous early American racing car is certainly the 1906 Locomobile racer known as "Old 16." This was the first American automobile to win the Vanderbilt Cup auto race. Old 16 is now on display at the Henry Ford Museum in Dearborn, Michigan.

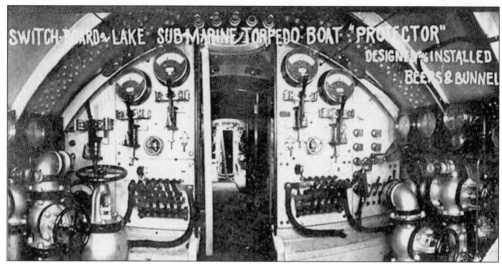

Simon Lake designed the Protector in 1901–1902, an innovative submarine design that was used by Russia in the Russo-Japanese War. Shown inside the submarine is the switchboard of the Protector.

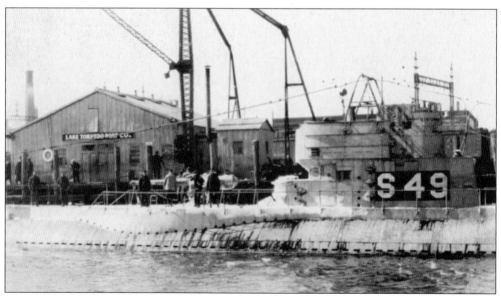

Simon Lake's factory was right off Seaview Avenue. Lake liked Bridgeport because of its easy access to Long Island Sound's protected waters and the Atlantic Ocean beyond.

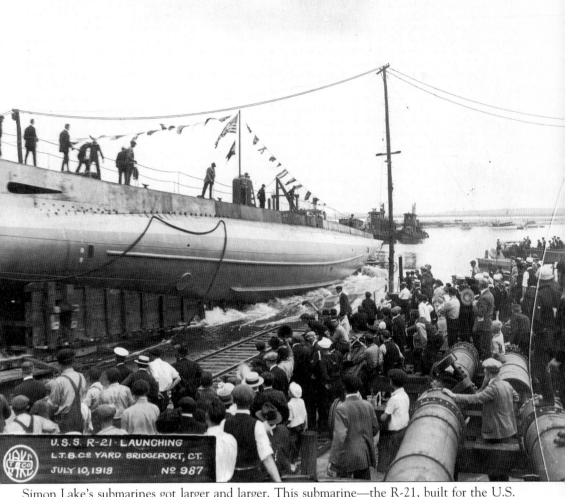

U.S.S. R-21 LAUNCHING
L.T.B.Cº YARD. BRIDGEPORT, C.T.
JULY 10, 1918 Nº 987

Simon Lake's submarines got larger and larger. This submarine—the R-21, built for the U.S. government—gets a launching party off Seaview Avenue on July 10, 1918. The company was extremely busy during World War I, filling government contracts. The company's motto became "No slacker at the Lake."

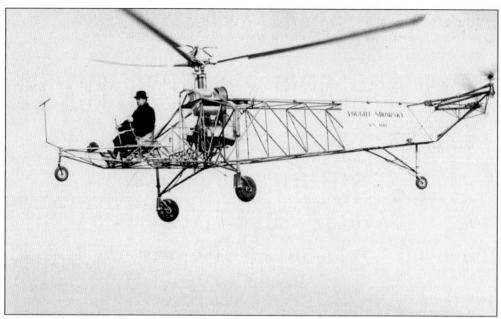

Igor Sikorsky experimented in building helicopters first in his native Russia and then in the United States. His first successful launching of a direct lift helicopter was on September 14, 1939, in Stratford. Sikorsky built his first helicopter assembly line on South Avenue in Bridgeport after receiving a contract with the U.S. government in the late 1930s. Here, wearing his customary hat, Sikorsky tests his VS-300 over Stratford Meadows.

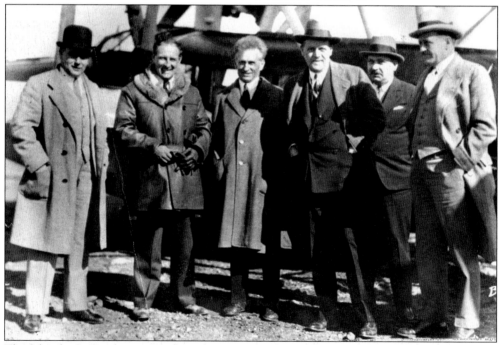

The Sikorsky S-42, a long-range flying boat, captured the world's altitude records for the United States in tests held in Bridgeport in 1934. These participants, including Capt. Boris Sergievsky (second from left) and Igor Sikorsky (second from right), pause to document the moment.

TEAS AT IMPORTERS' PRICES.

GREAT ATLANTIC & PACIFIC TEA CO.,

290 Main Street,

BRIDGEPORT, CONN.

JOHN PETERSON,

House, Ship and Fresco Painter.

George Gilman began his business with the selling of tea, coffee, spices, and baking powder at 290 Spring Street in New York City in 1859. With the aid of his partner and manager, George H. Hartford, Gilman opened stores called the Great Atlantic & Pacific Tea Company (A & P), selling imported tea and other goods throughout the country. One of those stores was at 290 Main Street in Bridgeport. Gilman never allowed more than 290 A & P stores to open because he thought there was "magic" in the number 290. It was the address of his original New York store, the Bridgeport store, and his post office number. After A & P expanded to 290 stores, one of them had to be closed in order to open a new one. Here is a page from the 1877 city directory.

George Gilman bought a house in the Black Rock section of Bridgeport near Grovers Avenue. The 1762 Colonial, first owned by Nehemiah Bun, burned on November 7, 1894, with Gilman and his servants narrowly escaping. Gilman then built a large manor house, a 20-room mansion with a bathroom built between every other room. Known as an expansive host, he entertained guests between their New York-to-Newport trips. A well-dressed, genteel man, Gilman had some peculiar traits that became better known after his death. He would not allow anyone ill to be around him and, in fact, sent one of his best friends directly to the hospital when he became ill while visiting the Black Rock residence. Gilman also allowed no mirrors in his home, hated photographs, and in his final years thought his relatives were trying to kill him. Gilman never married, and his father's stepchildren and other family members contested the father's will. Because of this, he was very leery about anyone knowing the value of his estate. He died in Bridgeport without a will in 1901. His estate, claimed by all living relatives, was valued at $75 million.

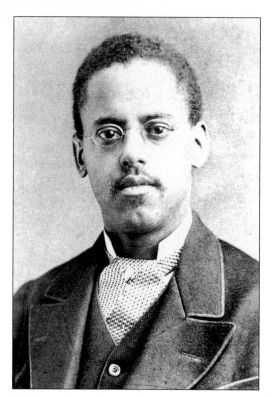

Louis Latimer came to Bridgeport in 1879 to work as a draftsman for Hiram Maxim, the inventor of the machine gun and head of the United States Electric Lighting Company. The following year, Latimer and fellow inventor Joseph V. Nichols received a patent for their invention of the first incandescent light bulb with a carbon filament. Prior to this breakthrough, filaments had been made from paper. Latimer was a member of Bridgeport's Scientific Society. The company had moved to New York by 1880, but it was in Bridgeport that Latimer's first important discovery was made: the first incandescent light bulb.

Baseball may not seem like a "working" profession to some people, but professional ball was played in the city. In 1945, one of Bridgeport's most famous pro baseball players was inducted into the Baseball Hall of Fame in Cooperstown, New York. James O'Rourke began playing baseball in the grassy fields of the East End. By 1871, he was getting paid to play ball on the Middletown Mansfields. O'Rourke helped lay the foundation of baseball in Bridgeport by his involvement in the Connecticut League, which later became the Eastern League. He also developed Newfield Park as a baseball field.

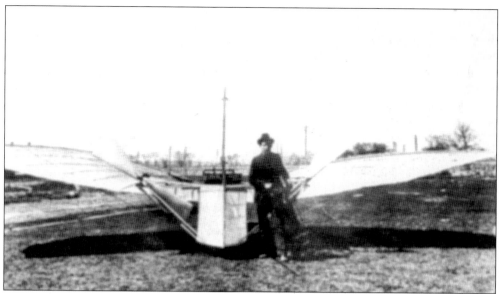

The August 18, 1901 *Bridgeport Sunday Herald* reported an eyewitness account of an astounding nature: Gustave Whitehead, a German immigrant, flew his propeller-driven plane (known as No. 21) for 10 tenuous minutes near the waters of Long Island Sound. Newspaperman Richard Howell, who covered the event, reported that the inventor said he "could fly like a bird." Two other witnesses at the flight were Whitehead's two assistants, Junius Harworth and Anton Yrucker. This 1901 flight was two years before the Wright Brothers historic "first flight" at Kitty Hawk. For years, many residents of Bridgeport saw Whitehead working on his plane in the backyard of his Pine Street residence. In 2001, citizens of Bridgeport celebrated the 100th anniversary of Whitehead's flight.

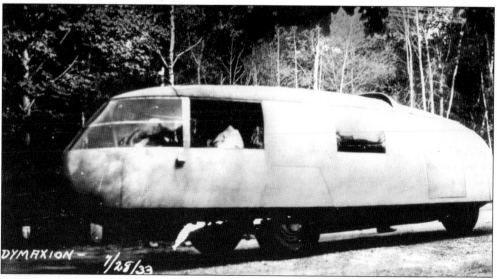

Inventor Buckminster Fuller used the old Locomobile factory at the foot of Main Street to build one of the strangest cars ever designed, the Dymaxion. Fuller and his partner, Starling Burgess, a yacht designer, built a sleek, three-wheeled vehicle that could run at a speed of 120 miles per hour. Although the Dymaxion was displayed at the 1933 World's Fair, the company went out of business by 1935.

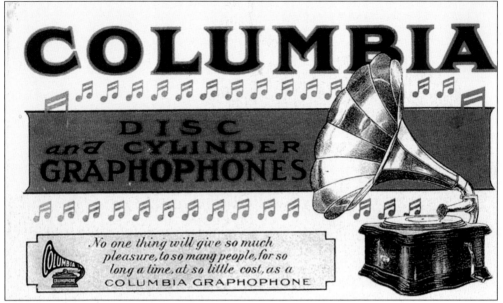

A 1904 advertising brochure for Columbia Graphophone shows prices ranging from $20 for the Jewel to $200 for the Symphony Grand.

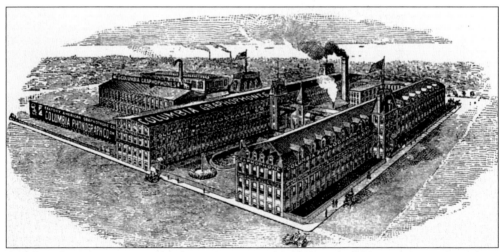

In 1888, the American Graphophone Company, located in the old Howe sewing machine factory at the corner of Howe and Kossuth Streets, was on the cutting edge of sound recordings. By 1897, the company was manufacturing a $10 graphophone operated by a small clockwork motor. By 1902, disc records were being made by the company under the name Columbia. The plant employed hundreds of Bridgeport residents; circus performers often worked in the plant during the off-season.

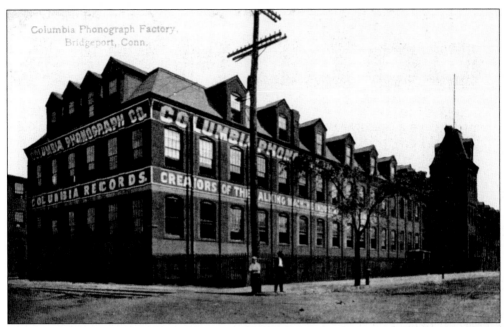

Early recordings were made at a studio in New York, but Columbia records were manufactured in the Bridgeport plant. Columbia produced the first recording of a complete symphony (Beethoven's seventh) at the Bridgeport factory in 1924. The first successful long-playing record was also produced in Bridgeport. When Columbia moved its factory to Barnum Avenue, it became the largest record-making plant in the world.

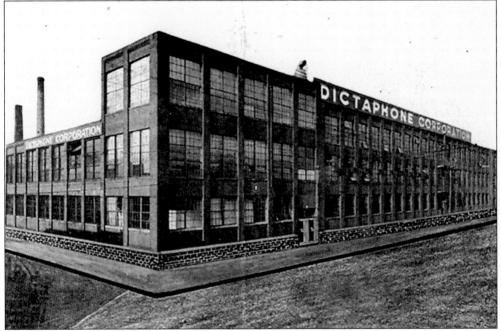

Chichester Bell, a cousin of Alexander Graham Bell, and Prof. Charles Sumner Tainter, who started the American Graphophone Company, began also to manufacture machines for the reproduction of sound by businesses in office settings. The product was named Dictaphone in 1923.

Bridgeport had the first dental hygiene school in the world, started by Dr. Alfred Fones, an 1890 graduate of the New York College of Dentistry. His father, Civilion Fones, also a dentist, served as mayor of Bridgeport from 1886 to 1887. Alfred Fones became a crusader in early oral hygiene and education. He opened his office at 10 Washington Avenue in a carriage house and, in 1913, opened a dental hygiene school on the premises.

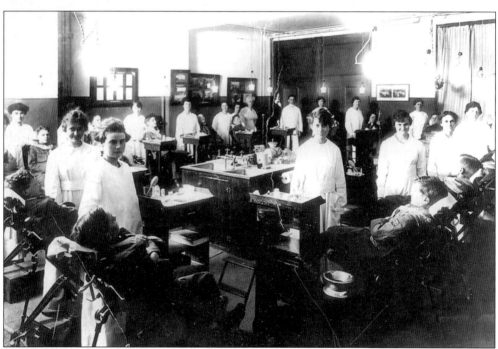

Thirty-four women were accepted into the first class at the Fones dental hygiene school. Many of them were mature women, schoolteachers, nurses, and doctor's wives. Dr. Fones and his assistant Irene Newman taught classes, inviting instructors from nearby Yale to speak. This c. 1915 photograph of the early classroom shows the young women practicing on Boy Scouts.

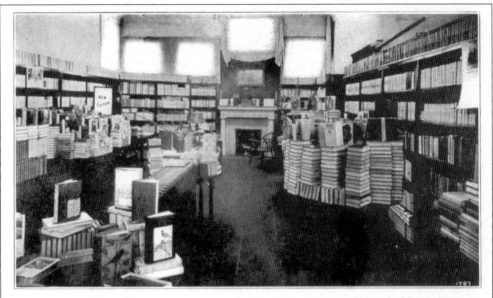

The Little Book Shop

THE D. M. READ COMPANY
Bridgeport, Conn.

It was during the Depression, on March 4, 1933, the day that Franklin D. Roosevelt closed the banks, that Lawrence Hoyt decided to go into business. A small rental library was opened in Read's Department Store on Broad Street, where anyone could pay 3¢ a day to enjoy popular novels that they could not afford to buy. The rental library proved to be a huge success, and by 1948, Hoyt had expanded his business to 250 locations. By the 1950s, Hoyt had changed his rental libraries to bookstores and, in 1962, opened up his first independently owned bookstore in Pittsburgh, Pennsylvania, calling it the Walden Book Store, as a tribute to Henry David Thoreau's classic, *Walden*. Waldenbooks is now the most successful mall-based bookseller in the United States. This photograph shows a book shop in Read's Department Store; in which corner was Hoyt's shop?

In 1887, George Hutchinson lived on Norman Street in the city and was the president of the Standard Card and Paper Company. Thomas Sperry was employed at the Wheeler and Wilson Sewing Machine Company. In 1896, Sperry and Hutchinson became partners and opened their first store, Merchants Supply Store, at 43 Cannon Street. A year later, the two built a trading stamp store, Sperry and Hutchinson Trading Stamps. The company became known as S & H Greenstamps and opened trading stamp stores throughout the country. Trading stamps were collected and redeemable for merchandise. The company still exists today as S & H Greenpoints.

WE GIVE
S.&H.
GREEN
STAMPS
Save
as you
spend

89

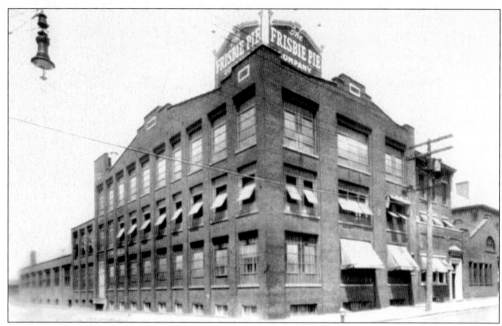

Bridgeport should take full credit for the idea of the game of Frisbee. When William R. Frisbie opened his bakery in Bridgeport in 1871, little did he know that his delicious pies would become famous instead for the tins they were baked in. Here is the Frisbie factory on Kossuth Street in Bridgeport's East Side.

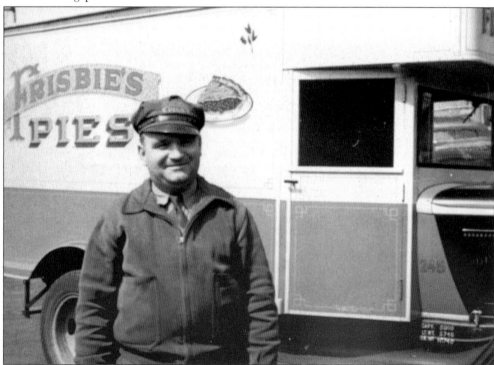

A driver of a Frisbie truck stands outside c. 1940. Legend has it that the drivers used to toss pie tins around in the parking lot.

90

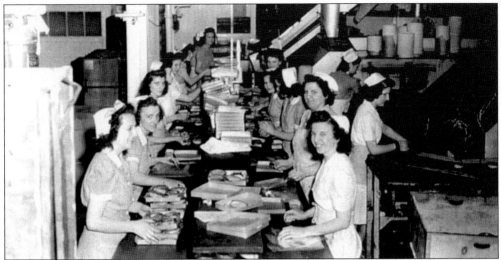

Women work on the line inside the Frisbie factory in the late 1930s. Employees of the company would toss the pie tins around in the parking lot on their breaks. Kids would line up to buy pies after school, and they too would toss the tins. Many Bridgeport residents remember buying broken pies for only a nickel. In 1957, Wham-O Corporation changed the name to Frisbee when it designed the plastic disc fashioned after the original pie plate. The Frisbie bakery closed its doors in 1958. The pie tins are highly prized collectibles today.

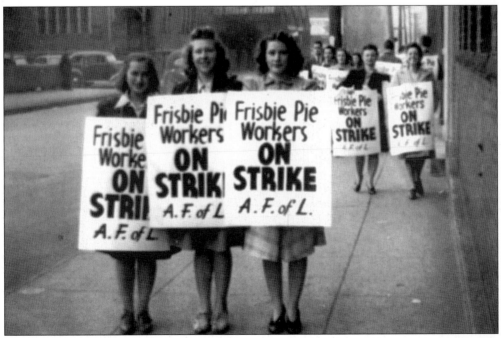

Workers are on strike outside the Frisbie plant c. the 1940s.

Elizabeth J. Bullard was the daughter of Oliver Crosby Bullard, a well-known landscape architect who worked with Frederick Law Olmsted on projects such as Prospect Park in New York and the national grounds in Washington. She worked side by side with her father and Olmsted on many of these projects. When her father was the superintendent of Bridgeport's parks, she planned many of the landscapes still being enjoyed today. She was the first female registered landscape architect in the United States. No photograph of her has been found, but her work can be seen in local parks. She died in 1916. This photograph of Beardsley Park is included in honor of Elizabeth Bullard.

Five

WAR WORK

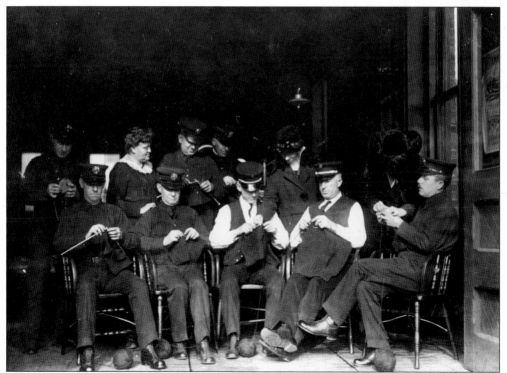

Firemen got into the World War I home front effort by learning knitting taught to them by a local woman. These men in uniform appear to be knitting sweaters for others in uniform overseas.

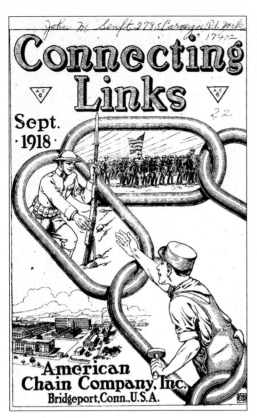

The American Chain Company published a newsletter called *Connecting Links* for its employees. The newsletter featured new products of the company, company functions, and war news.

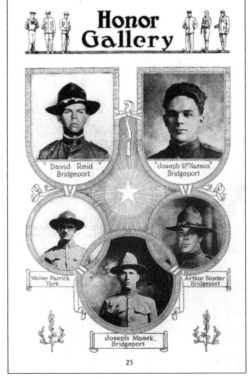

This September 1918 issue of *Connecting Links* shows the "Honor Gallery," American Chain Company workers who were then serving in World War I.

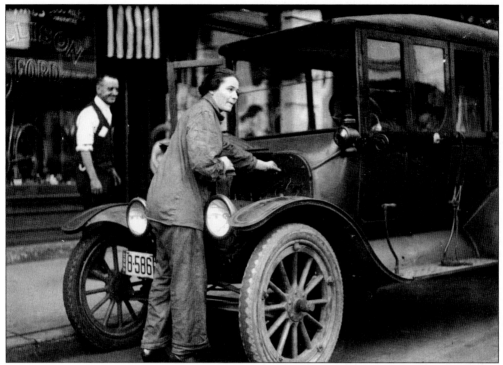

Women's roles changed drastically during World War I. At Ellison's Auto Tire and Repair Company c. 1918, a woman works as a mechanic fixing an engine as a man looks on. Notice the Ford sign in the window of the business, which was located at 371 Fairfield Avenue.

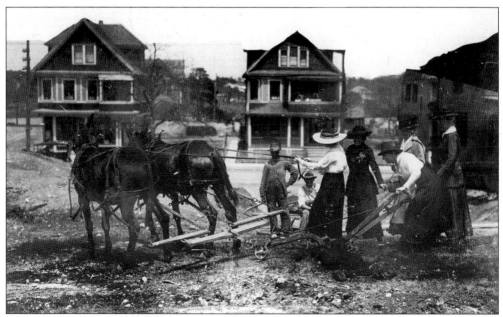

Liberty gardens were planted throughout Bridgeport in order to grow produce locally during World War I. These women plow rocky fields with the help of horses.

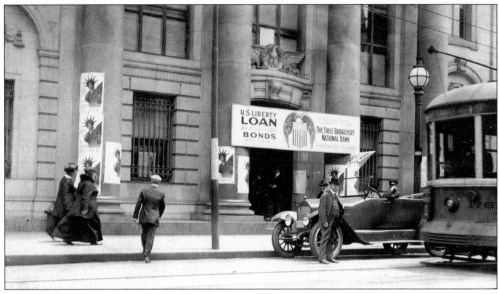

Liberty loan posters fly high over the entrance to the First Bridgeport National Bank, at the corner of State and Main Streets, in 1918.

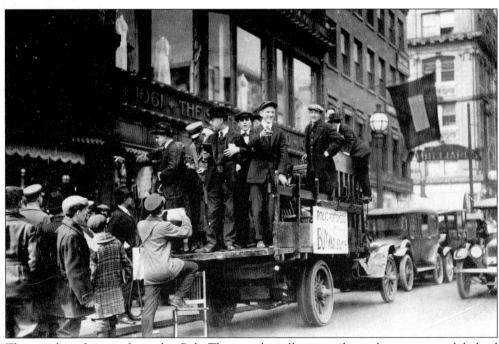

Theatrical performers from the Poli Theaters literally jumped on the wagon and helped Bridgeport letter carriers sell war savings stamps during World War I.

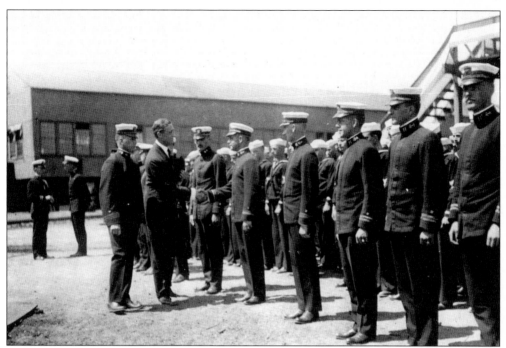

Franklin Delano Roosevelt visited the naval base in Black Rock during World War I. Navy secretary at the time, he was escorted by Mayor Clifford Wilson and other Bridgeport dignitaries. He also visited the Lake Torpedo Boat Company; the Remington Arms Plant, which had just been completed in 1915; and other factories.

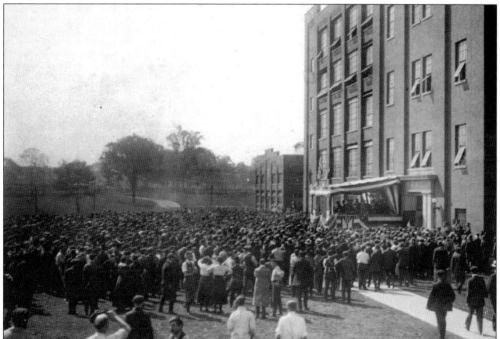

After visiting the naval base in Black Rock, Franklin Roosevelt visited the Remington Arms Plant.

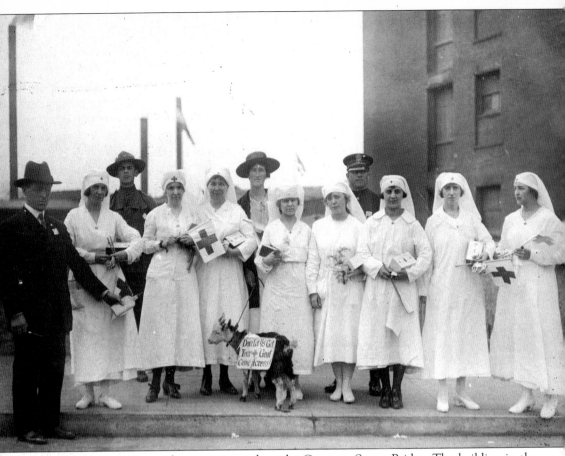

Red Cross Tag Day workers are pictured on the Congress Street Bridge. The building in the background is still standing on the East Side. Even the goat has a sign that reads, "Don't Let Us Get Your Goat. Come Across!"

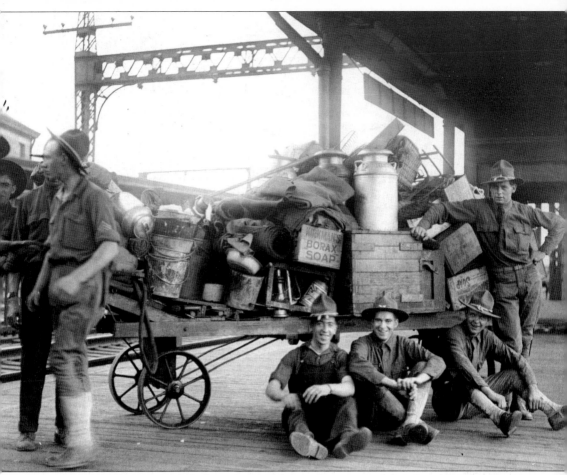

These soldiers with a wagon full of supplies stand near the train tracks at the railroad station.

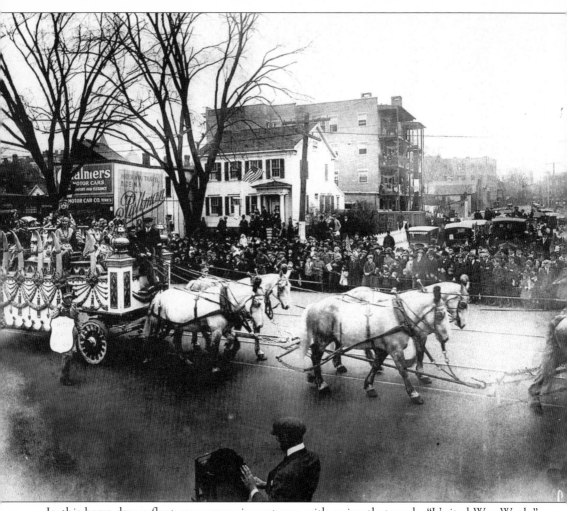

In this horse-drawn float are women in costume, with a sign that reads, "United War Work." On Park Avenue an unidentified black photographer stands in the forefront with a camera, ready to take a photograph. Taken in 1918, this photograph also shows people gathered on the steps of decorator E.B. Ellis's house.

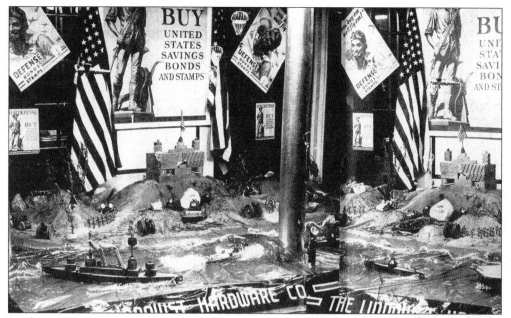

Lindquist Hardware on Fairfield Avenue took special delight in having George Jasmin put up a scale model of World War II activities made of hardware. The model was called *Camp Shelby*. The submarines were made of bolts and other metal goods; the soldiers were made of screws. This June 1942 photograph is from *Bridgeport Life*.

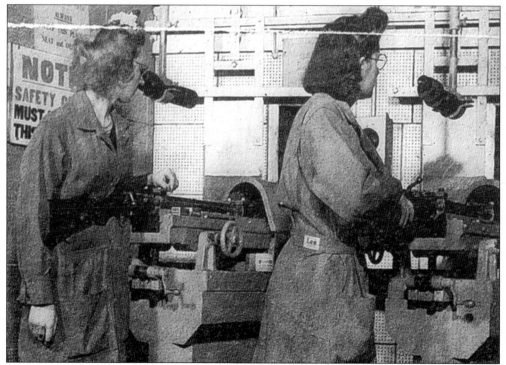

These women at Remington Arms are firing ammunition for accuracy tests on a 100-yard rifle range. Telescopes show the results.

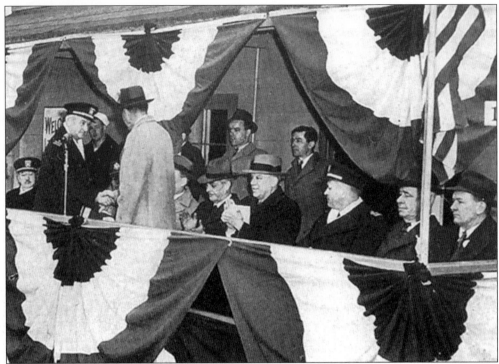

Shown is the presentation of the Army-Navy E Award at Harding Field on September 14, 1942. Remington Arms and several other companies received awards for their war work in the factories.

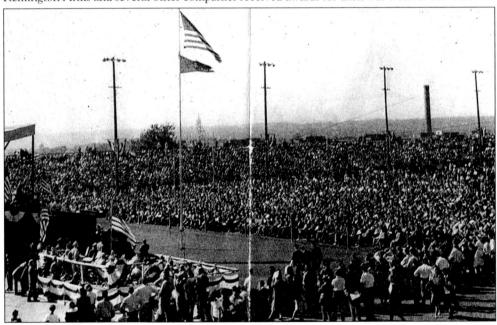

Employees of the Bridgeport Brass celebrate their sixth consecutive Army-Navy E Award for excellence in production. The ceremony took place at the North Yard of the Bridgeport Brass Housatonic plant between the first and second shifts on December 18, 1944, so that "no time was lost turning out the vital materiel of war," according to the company magazine.

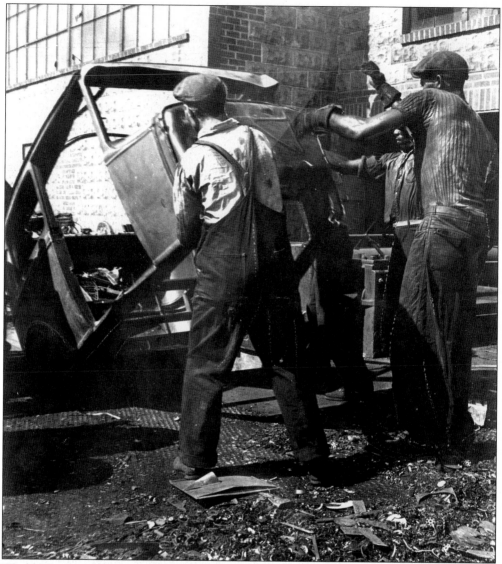

World War I and the boom in taking old metal and reusing it gave Samuel Jacob the idea to locate his scrap metal firm on Seaview Avenue in 1917. Jacob Brothers helped run scrap drives during World War II, when shortages of metal spurred hundreds of residents to salvage any metal they could get their hands on. This photograph of workers in 1941 shows the men taking old car remnants apart, probably to be used for metal for the war effort.

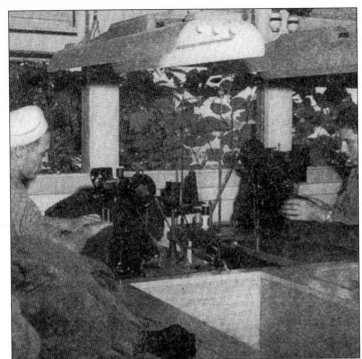

Navy men at Pearl Harbor, Hawaii, use industrial Singer sewing machines made at the Singer Bridgeport plant. They were repairing the clothes for their buddies in the Pacific fleet.

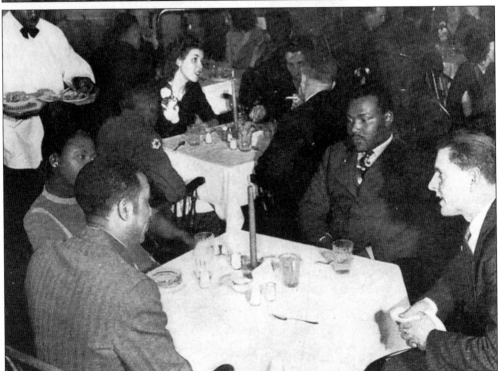

A welcome home dinner for returning veterans was held by Bridgeport Brass on December 28, 1944. Office manager Roy Walls (right) sits with John House and Mrs. and Mrs. Alfred Wilson at one table. A total of 51 veterans attended the dinner dance.

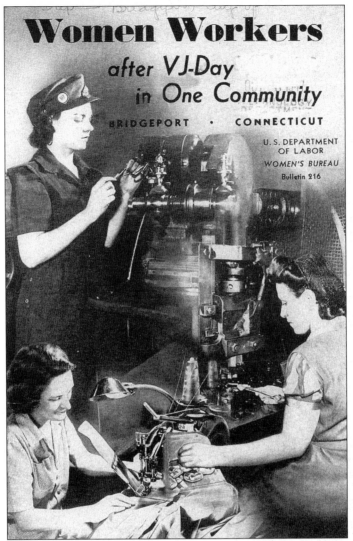

A 1947 U.S. Department of Labor publication entitled *Women Workers after VJ-Day in One Community: Bridgeport, Connecticut* details the changes in women's work in Bridgeport before, during, and after World War II. Three Bridgeport organizations, including the Young Women's Christian Organization (YWCA) worked with the U.S. Women's Bureau to study the characteristics of Bridgeport workers and their wartime and postwar jobs and employment problems. During the war years, the total number of women employed increased 85 percent from April 1940 to July 1943. In February 1946, women constituted about a third of the Bridgeport labor force. The two largest employers of Bridgeport women during the war years were the electrical industries and the apparel business, although women worked in all types of industries. For example, in metal and electrical plants, women worked as assemblers, punch press operators, drill-press operators, large-machine operators, and sewing machine operators. However, those who operated lathes, grinders, milling machines, and automatic screw machines during the war were quickly replaced by men after World War II. Cutters, the highest paid job for garment workers, were also replaced by men after the war. After World War II, the study found that unemployment was particularly serious among older women, married women, women without a high school education, and African American women.

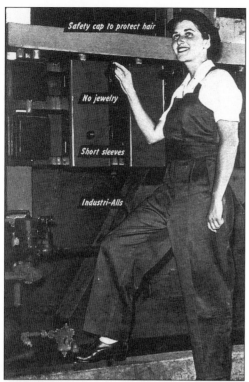

Marge Schneider answered the call when local companies asked for women to work in the factory, choosing to work as a safety inspector at the Bridgeport Brass plant. Her job was to make sure that women (and men) were doing their job safely. She was asked to model the correct clothing for women to wear when working with machinery.

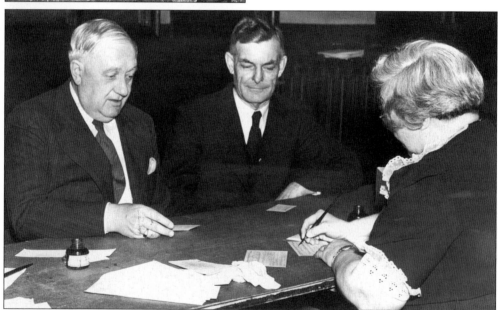

Many prominent men in the business and industrial life of the city were among those who registered for the fourth draft call. Mayor Jasper McLevy (center) was registered by Mrs. John M. Hurley (right) at a joint registration held by Draft Boards 22-A and 22-B. Also registering with the mayor was Charles F. Greene (left), a former postmaster and a member of the editorial staff of the Bridgeport Post. The fourth draft registration taken in 1942 included men born between April 28, 1877, and February 16, 1897. McLevy, born in 1878, was 64 years old in 1942.

Six

A WORKER'S LIFE

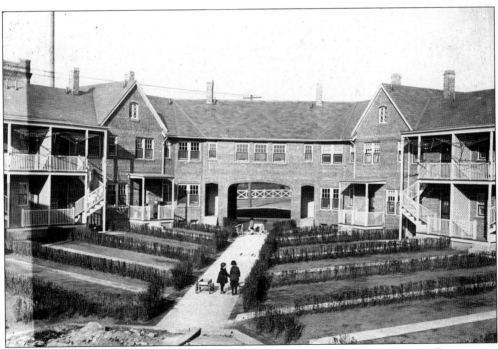

Gateway Village, on Connecticut Avenue, was built by the Bridgeport Housing Company to house the great influx of workers who moved to Bridgeport to work in the factories in the years 1917 to 1919. Planned communities like this one were the first of their kind in the nation. Note the newly designed courtyard with shrubs. War housing was built throughout Bridgeport, including Seaside Village and Old Mill Green.

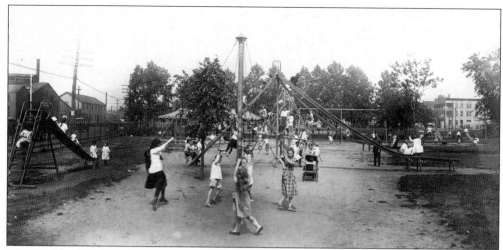

The neighborhood in which Yellow Mill Village was built was already known as Yellow Mill, named after the mill owned by Joseph Walker, which burned down in the late 1890s. Yellow Mill Pond is connected to Bridgeport Harbor, separating the city's East Side from the East End. This photograph of children in a neighborhood playground shows the diversity of the community in 1919: black and white children play together. This culturally mixed neighborhood shows the blend of the working class in Bridgeport during the early 20th century.

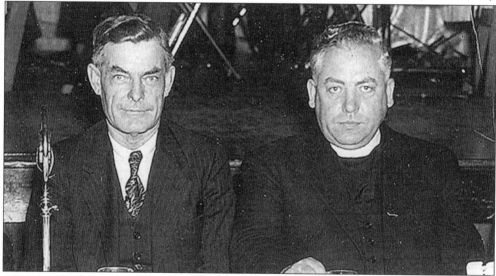

An article in the 1939 *Bridgeport Sunday Post* focusing on the opening of Yellow Mill Village began this way: "Future historians of the City of Bridgeport will undoubtedly transcribe as one the main news events of the coming decade, the transfer of hundreds of families, now unhappily known as 'slum dwellers' to a large group of attractive homes." A page from a brochure published to commemorate the opening of the first dwellings displayed the deplorable housing the new homes replaced. These slum and substandard dwellings—which were crowded and at times unheated and had rickety fire escapes—were torn down to build the new housing. When Yellow Mill Village was built in 1939 under the leadership of the Reverend Stephen J. Panik, the average family who moved there included a father who worked in a factory for about 55¢ an hour, and a mother who did not work outside of the home. Here, Father Panik sits at a dinner for Sts. Cyril and Methodius at the Stratfield Hotel with Mayor Jasper McLevy.

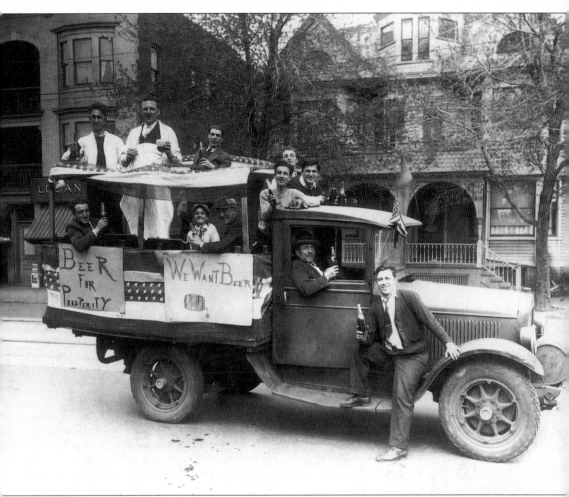

The signs alongside this truck on East Main Street read, "Beer for Prosperity." The dry years during Prohibition caused many local residents heartache because of the loss of revenue. These fellows, however, seem to be taking it all in good spirit *c.* 1932. From left to right are the following: (front row) Tony Van, ? Pederson, John Corvino, Anthony Vena (in cab), and Paul Corvino; (back row) James Aurigemma, Bill LaBrenz, unidentified, Jim Sullivan, and Sal Supersano.

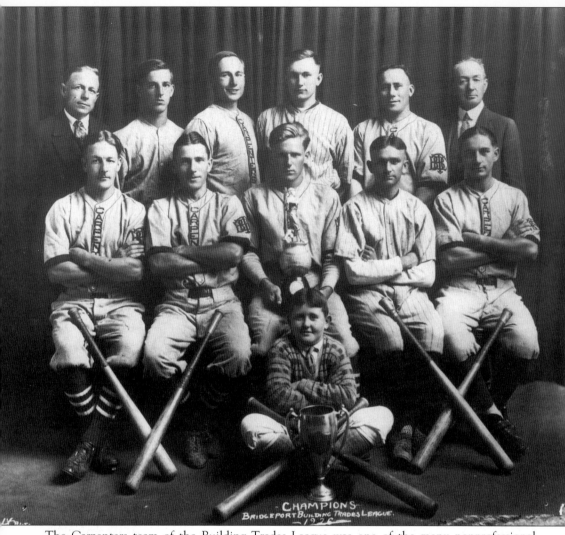

The Carpenters team of the Building Trades League was one of the many nonprofessional baseball teams that were formed in the Park City at the time. Leagues like this one and the Bridgeport Industrial League had teams formed by employees of Warners, the American Graphophone, the Crane Company, and the Yost Typewriter Company. These industrial league teams competed in the national Industrial League Championship, such as the one that Singer Sewing Machine won in 1914 by defeating a South Bend, Indiana team in Seaside Park. Teams also played in Newfield Park.

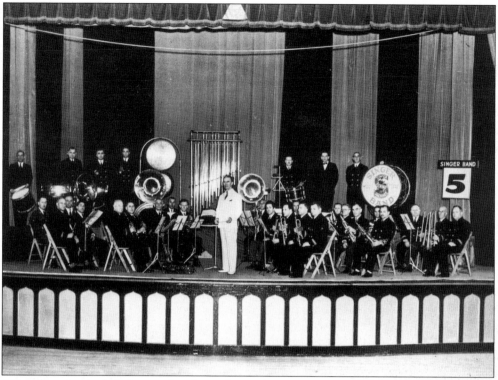

Many factories had their own band, ready to play at any event. Here the Singer Sewing Machine Band plays on unidentified stage.

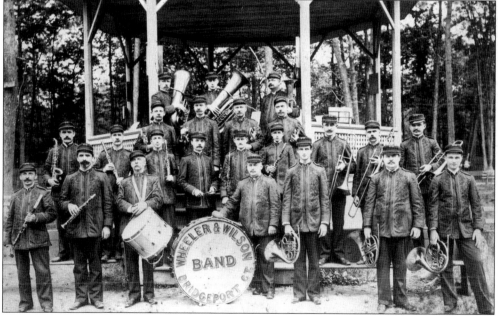

The Wheeler and Wilson Band was invited to every official and unofficial event in the city. Often, however, the band was asked to play near the Wheeler and Wilson factory in the Washington Park bandstand.

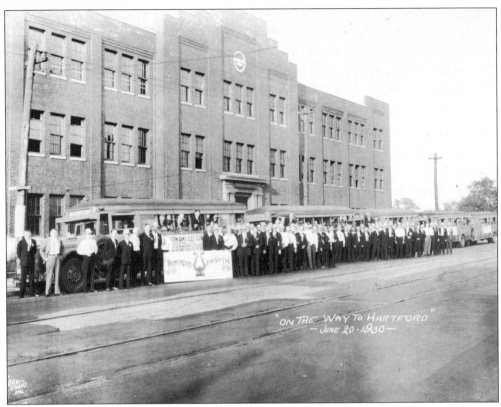

Remington Arms actually had its own glee club. Here, the band is leaving to perform in Hartford on June 20, 1930.

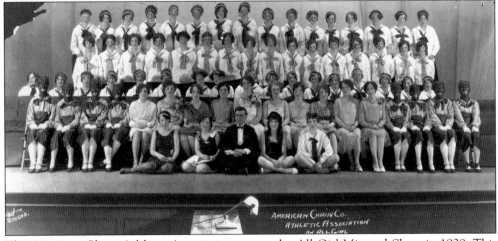

The American Chain Athletic Association put on the All-Girl Minstrel Show in 1929. This was during the days when Al Jolson still performed in blackface, a theatrical performance that was soon unacceptable.

Employees of the Bead Chain Manufacturing Company enjoy their company picnic at Eichner's Farm on June 26, 1948.

Moore Special Tool Company held its annual outing on September 17, 1938.

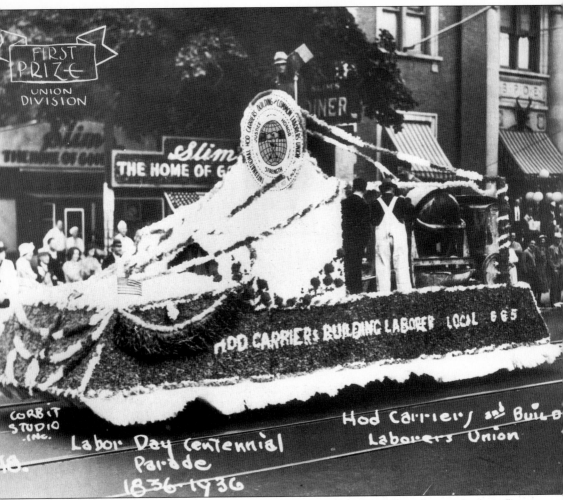

Before the days of the Barnum Festival, Labor Day parades always brought out the best floats. The Hod Carriers and Building Laborers Union won the first prize in the Union Division in 1936. This photograph was taken in front of Slim's Diner, on State Street.

In the 1918 Labor Day parade, members of the Bakers Union showed their spirit and their need for consumers to eat bread with union labels.

The Lake Submarine Company had a boat decorated for a 1918 parade at Main and State Streets.

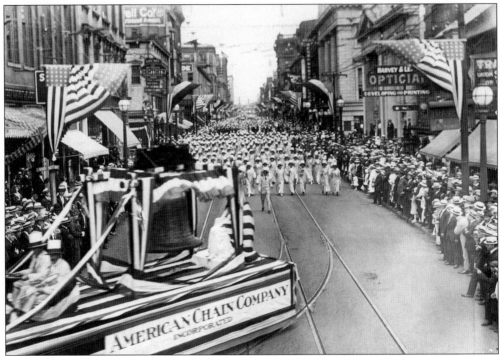

A red-white-and-blue-themed American Chain Company float turns the corner on State Street in the 1918 Labor Day parade.

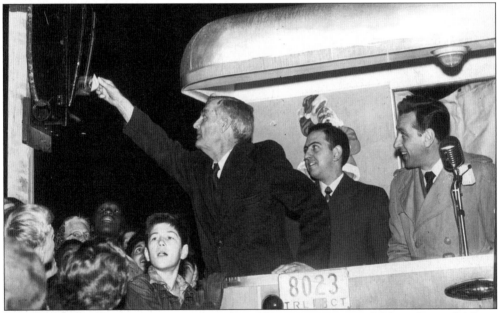

Saying "A Merry Christmas to you all, and God bless you every one," Mayor Jasper McLevy pulled the switch, marking the beginning of the Christmas season for the East Main Street merchants. Looking on at the November 29, 1949 ceremony were numerous children; Edward Voccola (center), the president of the East Bridgeport Merchants and Professional Men; and Nicholas De Piano, master of ceremonies.

Seven

PRIDE OF WORK

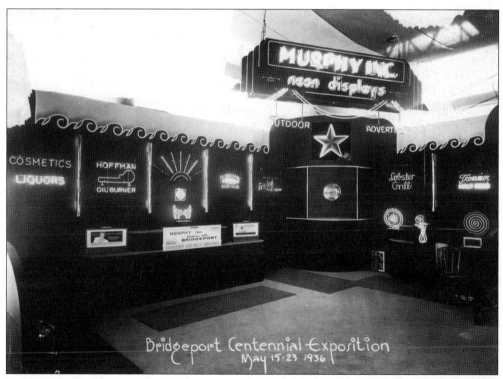

In 1936, Corbit Photography Studios was on hand to photograph the Bridgeport Centennial Exhibition in Seaside Park. The following pages are a series of photographs of this exhibition. Local companies exhibited with pride their most choice products. Here, Murphy Signs showed off the art deco designs of neon in a dramatic display.

Singer Sewing Machine showed a wide array of modern machines, as well as some built by the company in the past.

The newer electric sewing machines and industrial sewing machines were also on display and could be tested by consumers.

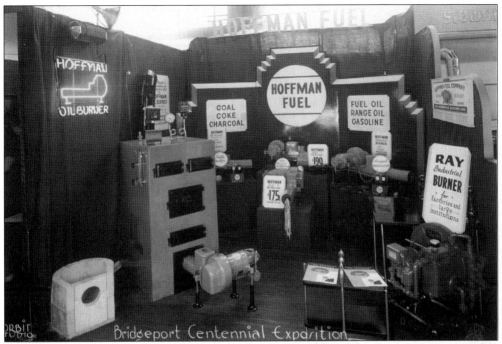

Hoffman Fuel got in the spirit of exhibition by showing the latest in oil burners and large factory furnaces.

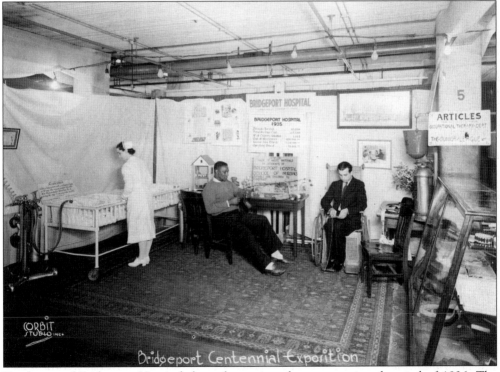

Employees of Bridgeport Hospital show the various departments in a hospital of 1936. The occupational therapy clinic and the school of nursing are particularly highlighted.

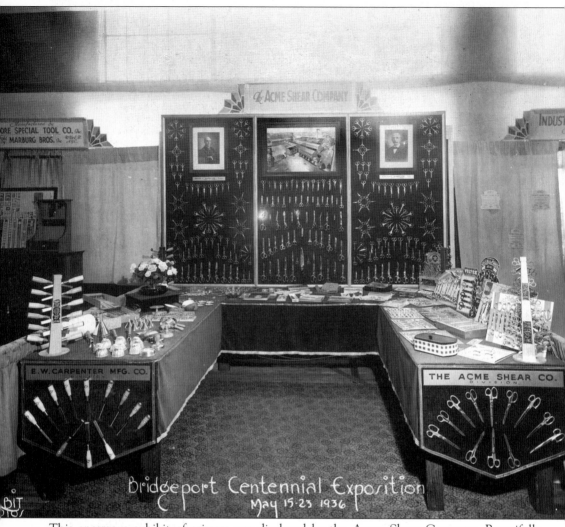

Bridgeport Centennial Exposition
May 15-23 1936

This enormous exhibit of scissors was displayed by the Acme Shear Company. Beautifully arranged, it shows everything from embroidery scissors and manicuring shears to the large knives and other items made by the company. The company was founded in Bridgeport in 1876 by Dwight and David Wheeler. Located on Barnum Avenue, the company produced more than 200 patterns of shears and scissors in 1936.

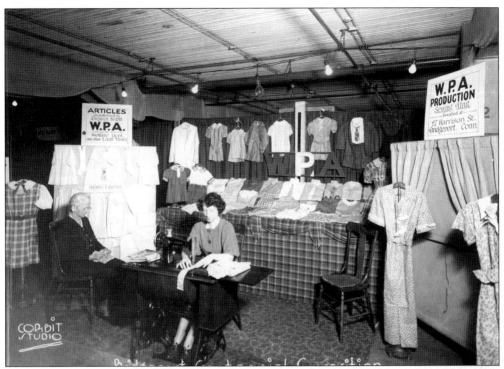

The Works Progress Administration (WPA), begun by Pres. Franklin Delano Roosevelt, displays the sewing unit located on Harrison Street. Items sewn by WPA workers were exhibited.

The latest in radios and record players designed by Capehart were on display. Note the side-playing phonograph players.

Even the Crawford Laundry Company got into the spirit. These women showed the detailed sewing work that they could supply for uniforms and other linen supplies. The woman on the left is doing machine embroidery.

The Bridgeport Parks Department actually planted a model cactus garden in an open space beside one of Bridgeport's factory buildings. Exactly where this garden was and whether it grew are questions that remain to be answered.

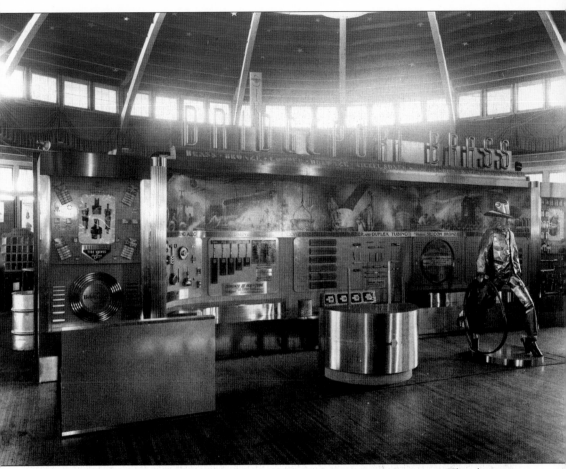

A brass cowboy "lassos" customers to the booth of the Bridgeport Brass Company. The gleaming artful display also shows murals by artist Robert Lamdin under the sign Bridgeport Brass.

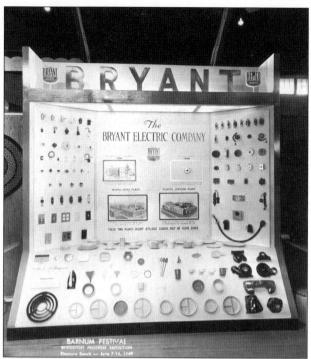

Bryant Electric showed its products in 1949 at the Bridgeport Progress Exposition at Pleasure Beach. Displayed are the various plants of the company and its products.

Manning, Maxwell, and Moore's simple exhibit shows off the regular valves, gauges, and safety valves produced by the company.

Speaking of pride in work, many of the photographs used in this book were photographed by longtime Bridgeport photography studio Corbit's Camera Shop. Lewis Corbit Sr. and Lewis Corbit Jr. are responsible for documenting almost a century of Bridgeport history. Lewis Corbit Sr. opened his photography studio in 1907, the day of a disastrous fire on Steeplechase Island, and he never stopped taking photographs of the city's daily events. In fact, he was hired by the New York Times to cover events in Fairfield County. Lewis Corbit Jr. continued to run his father's business, a constant and familiar figure running around Bridgeport taking photographs. Thanks to Corbit Studios and to Edna Fransesconi, who preserved it for years to come. This photograph was taken by Corbit Studios in 1934. On the left is Lewis Corbit Jr., with his brother Lawson standing in the center.

EPILOGUE

The Historical Collections of the Bridgeport Public Library staff began a project in 1999 called *Bridgeport Working: Voices of the 20th Century*. The intent of the project was to look at the subject of work in Bridgeport; who worked, where they worked and when they worked in the 20th century. After completing a series of oral history interviews, the staff searched archival materials and gathered photographs to produce a Web site that would be accessible to everyone. The Web site is a colorful display of the activities of Bridgeport citizens in the 20th century. By accessing it, viewers can not only read the oral histories but also listen to the voices. For more information on the subject of work in Bridgeport, please go to www.bridgeporthistory.org.

BIBLIOGRAPHY

Barnum, P.T. *Struggles and Triumphs*, Hartford: J.B. Burr, 1869.

Bucki, Cecelia. *Bridgeport's Socialist New Deal, 1915–1936 (The Working Class in American History)*, University of Illinois Press, 2001.

Danenberg, Elsie Nicholas. *The Story of Bridgeport*. Bridgeport Centennial, 1936.

Grimaldi, Lennie. *Only in Bridgeport: An Illustrated History of the Park City*. 1st ed. Northridge, California: Windsor Publications, 1986. 2nd ed. Harbor Publishing, 1993.

Orcutt, Samuel. *The History of the Old Town of Stratford and the City of Bridgeport*, New Haven, Connecticut: Tuttle, Morehouse and Taylor, 1886.

Palmquist, David W. *Bridgeport: A Pictorial History*. Virginia Beach, Virginia, 1981, 1985 editions.

Sherwood, Mabel. *Industrial History of Bridgeport*, a series of articles written for *Bridgeport Life*, 1936.

U.S. Department of Labor Women's. *Women Workers after VJ-Day in One Community Bridgeport, Connecticut*. Bulletin No. 216. Washington, D.C. GPO, 1947

Waldo, George C., Jr. *History of Bridgeport and Vicinity*. S.J. Clarke Publishing Company, 1917.

Witkowski, Mary, and Bruce Williams. *Bridgeport on the Sound*. Charleston, South Carolina: Arcadia Publishing, 2001.

INDEX